BLUE SIGHT STUDIOS, LLC.
PRESENTS

ART
OF
HECTOR J. ORTEGA

This is a work of fiction. Names, characters, places, and incidents either are the product of the author's imagination or are used fictitiously. Any resemblance to actual persons, living or dead, events or locales is entirely coincidental.

PERMANENT ADDICTION VOLUME ONE: THE ONE ABOUT OCTOBER

All rights reserved.

Published by **Blue Sight Studios, LLC.**
Copyright©2019 by Hector J. Ortega

No part of this book may be reproduced in any manner without written permission except in the case of brief quotations included in critical articles and reviews. For information please contact Blue Sight Studios,LLC.

First Printing: January 2019
Printed in the United States of America.

First Edition: January 2019

ISBN: 978-0-578-44151-1

SPECIAL THANKS!

I want to thank my mom who continues to believe in me by showing me support in every move I make with my art. My kids, my son Hector and my daughter Zoe for continuing to give me a reason to keep pushing forward. And I also want to thank those who continue to show me support and love throughout my journey to success. THANK YOU!

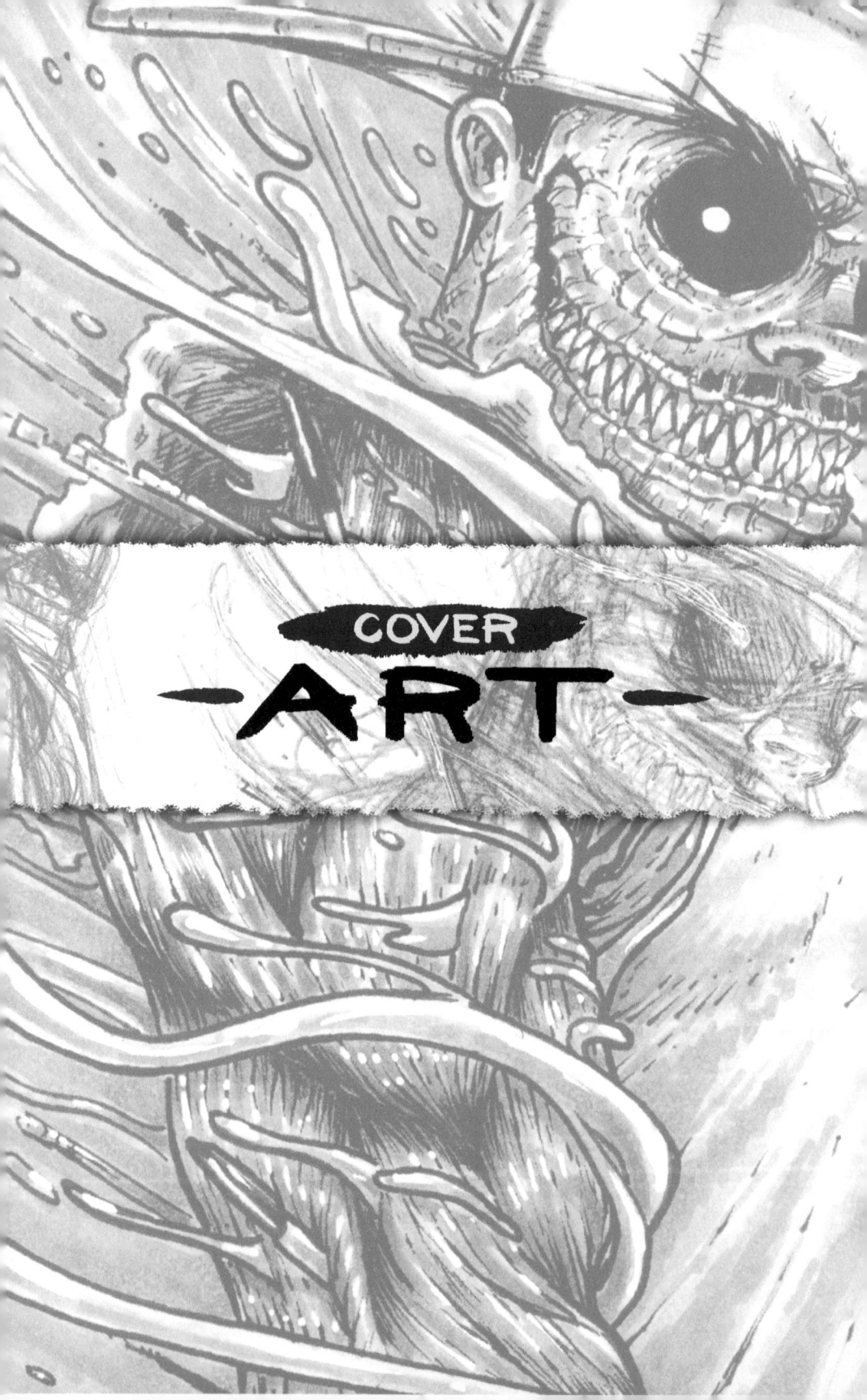

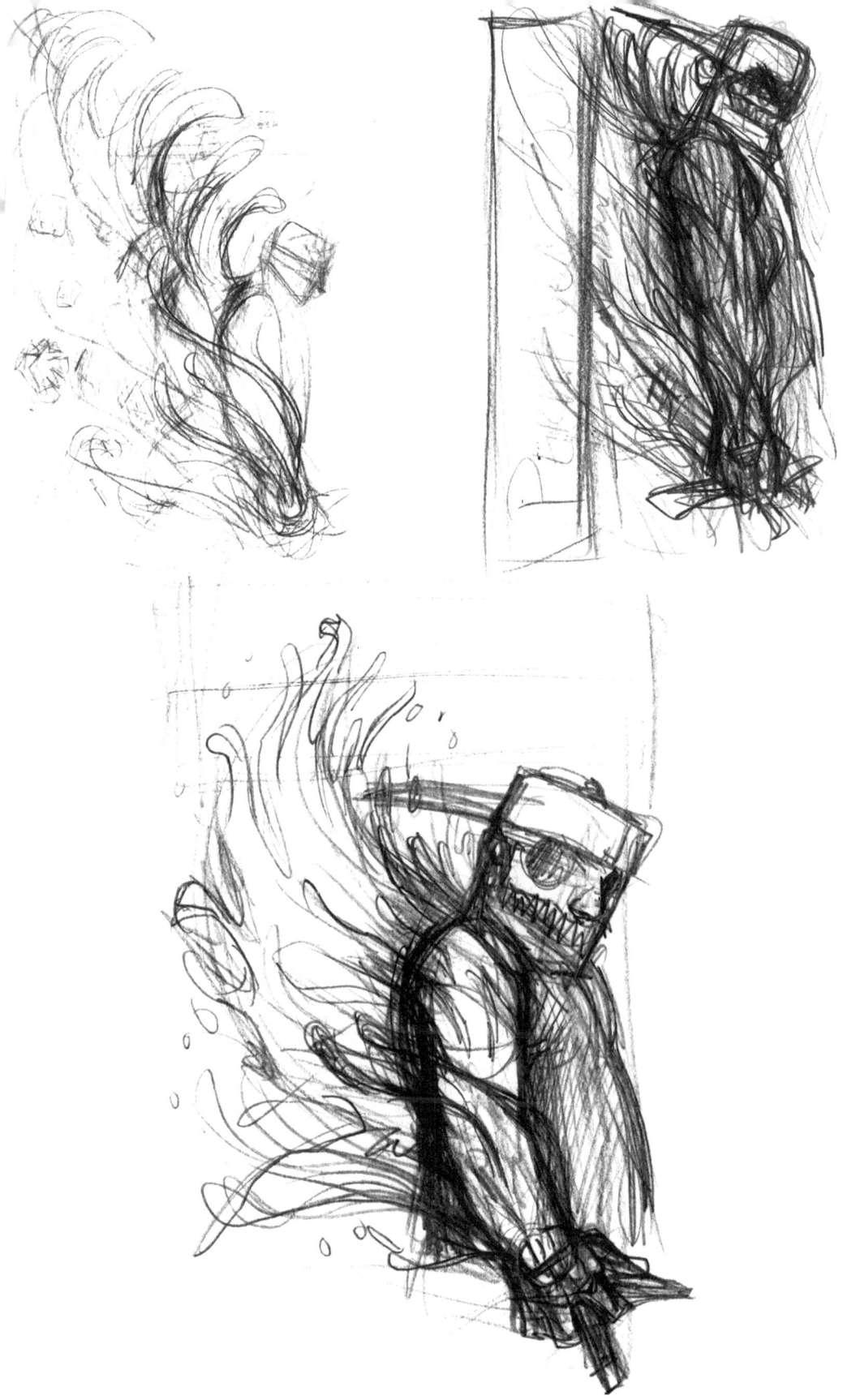

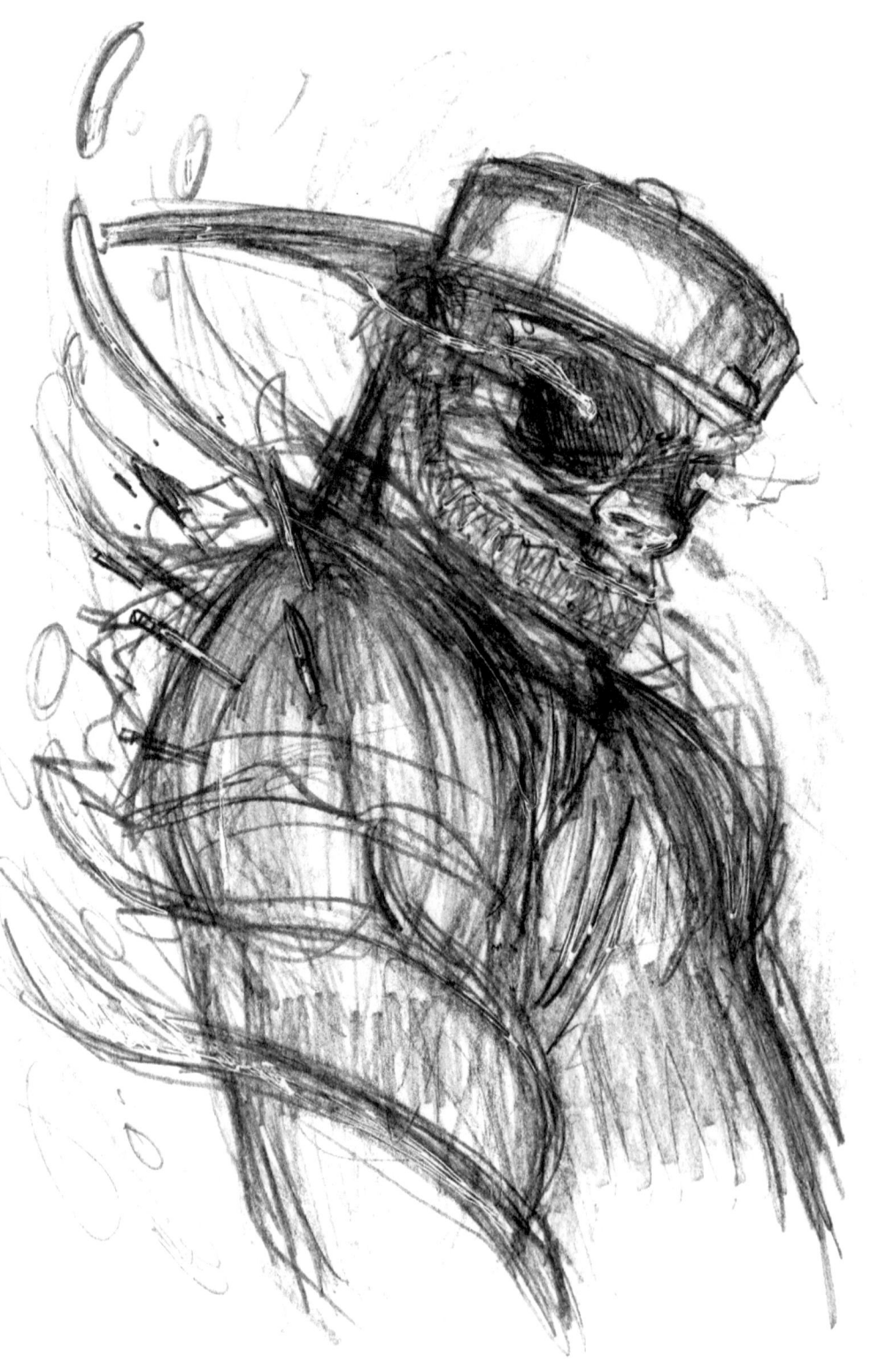

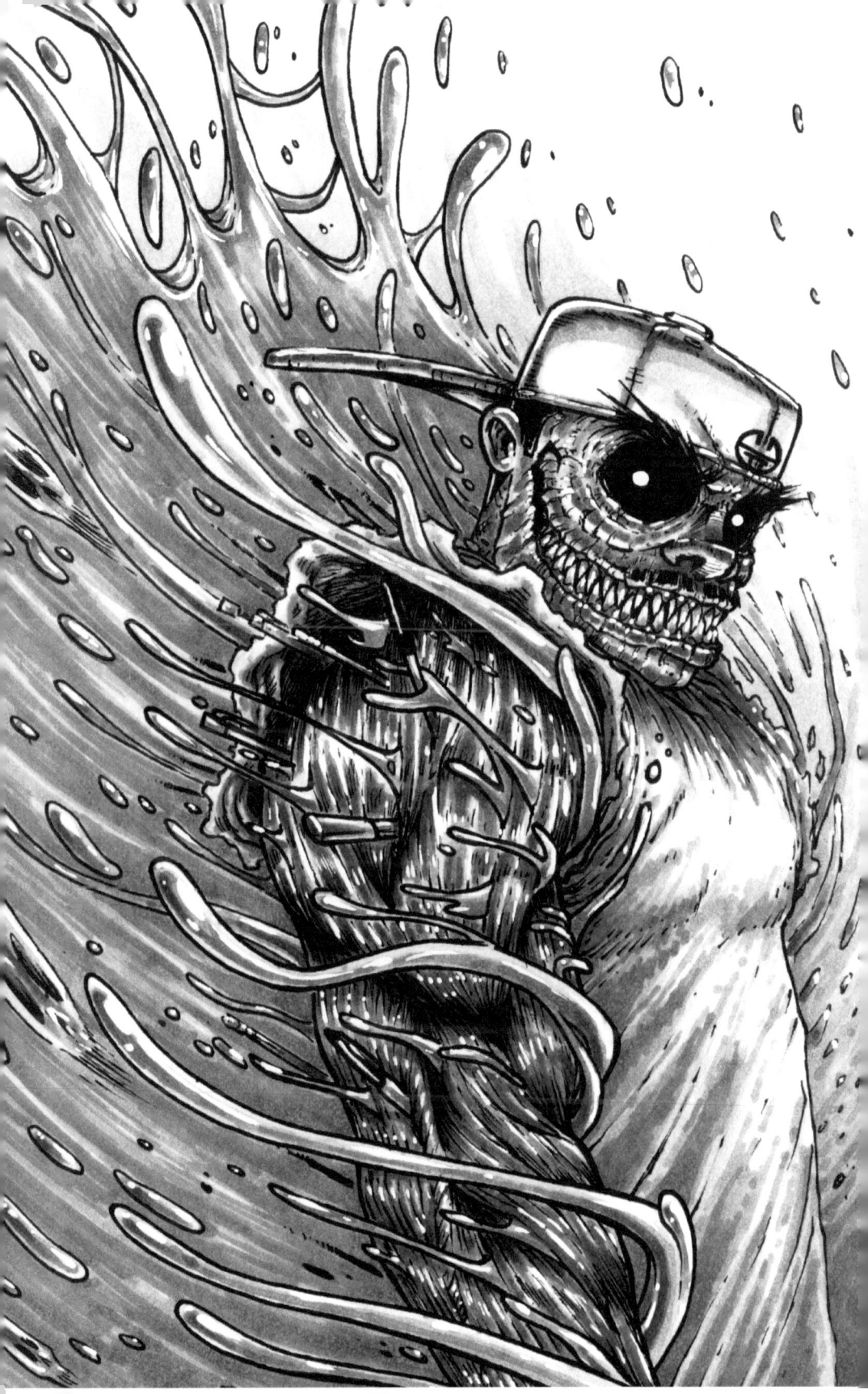

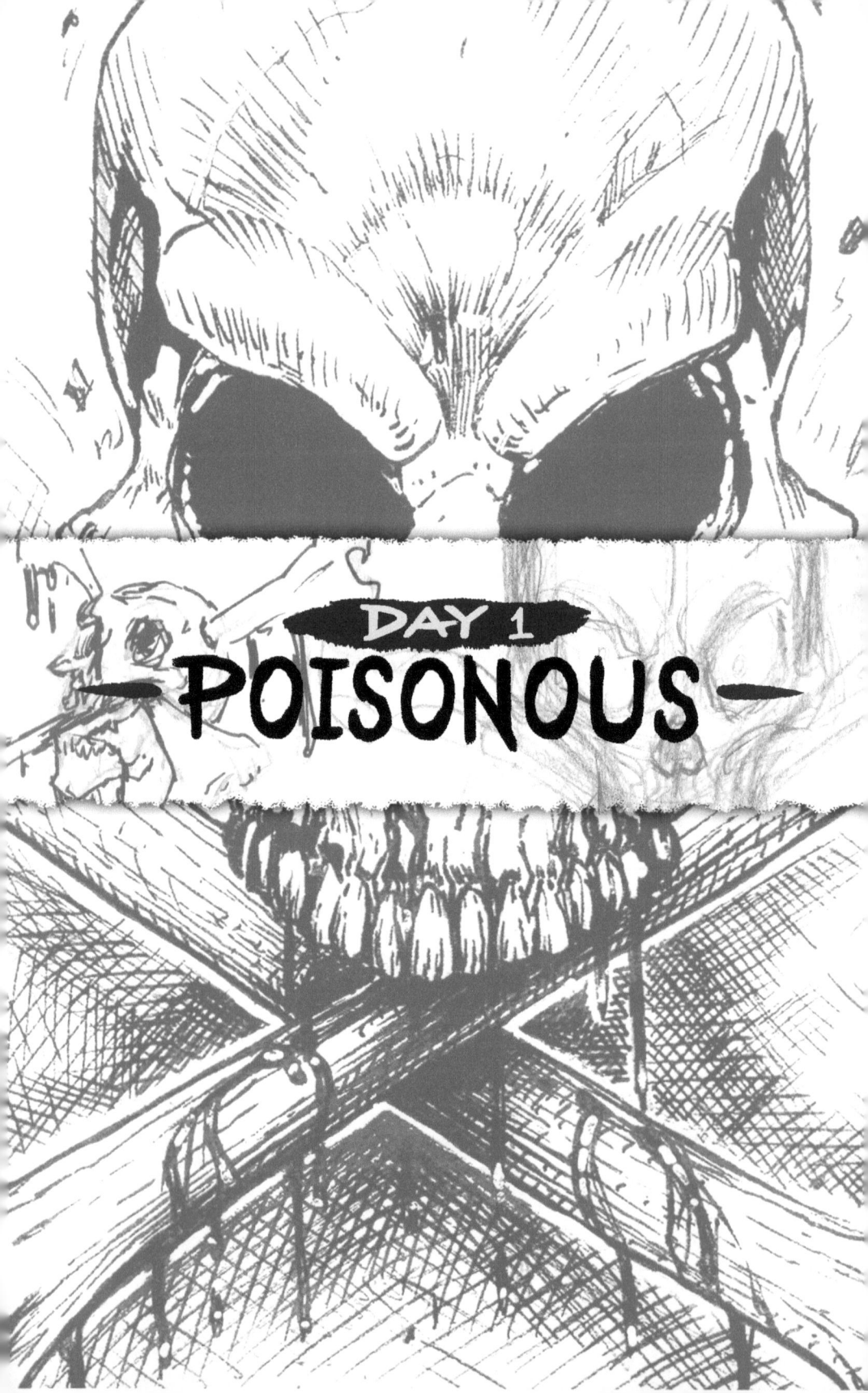

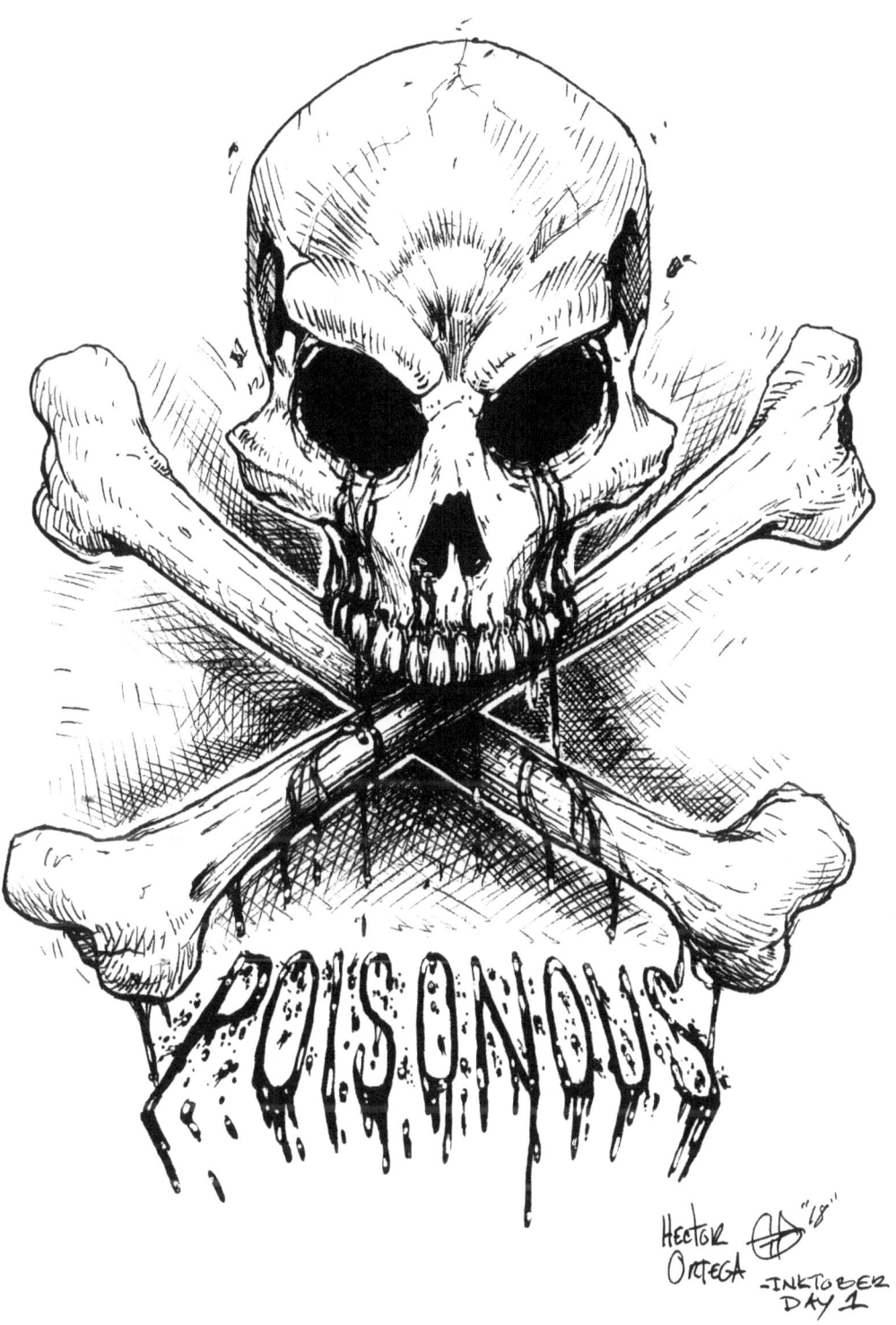

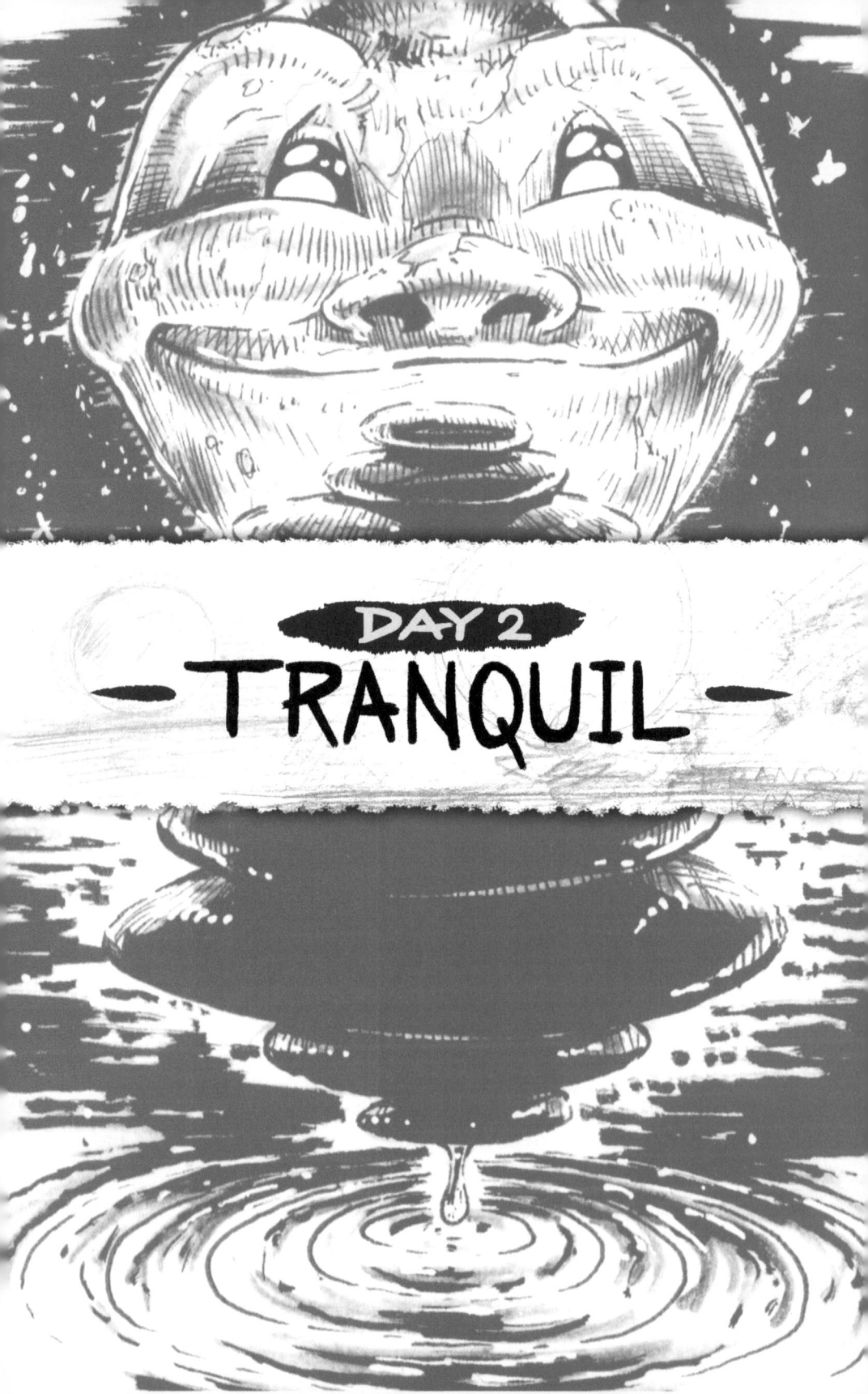

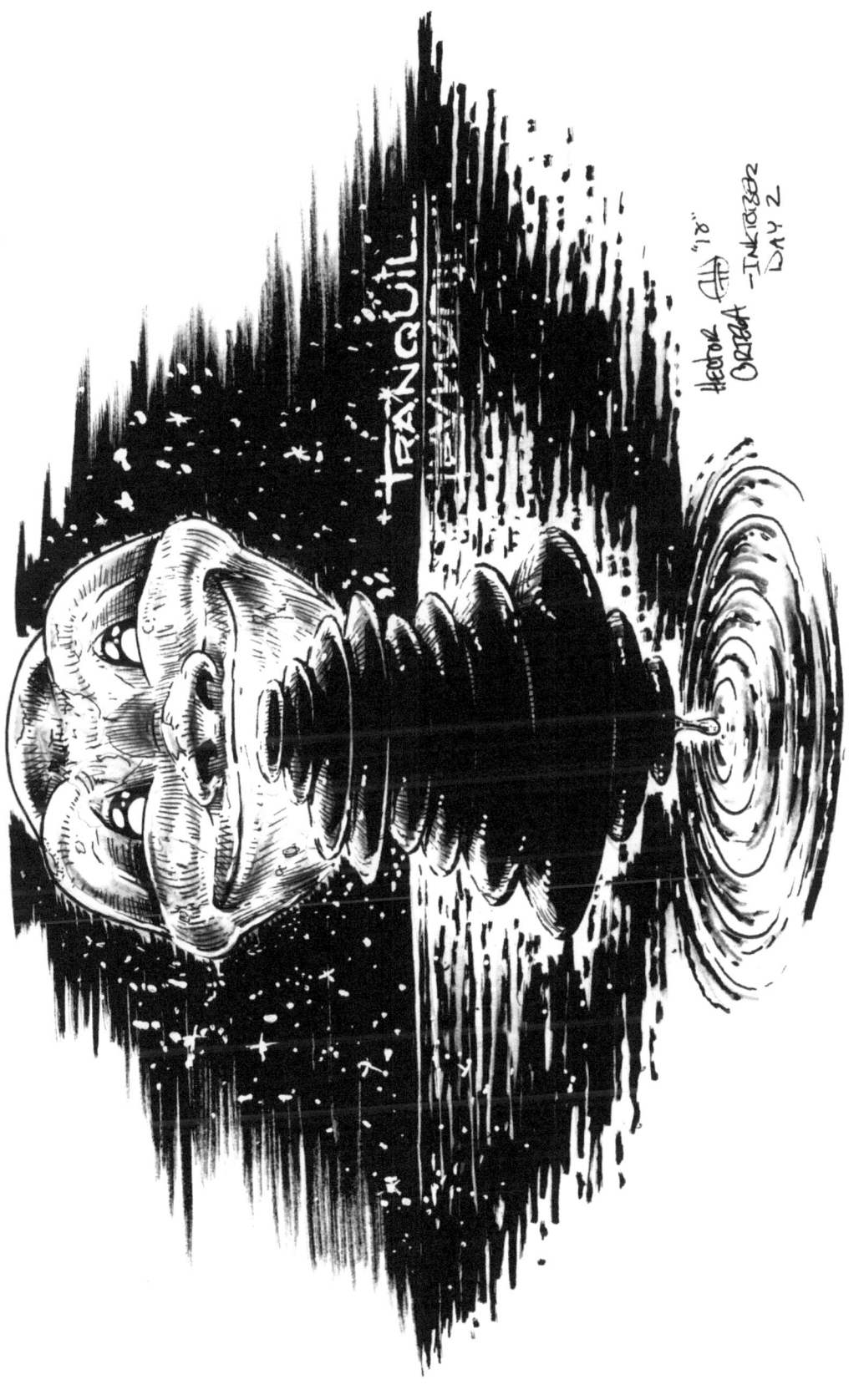

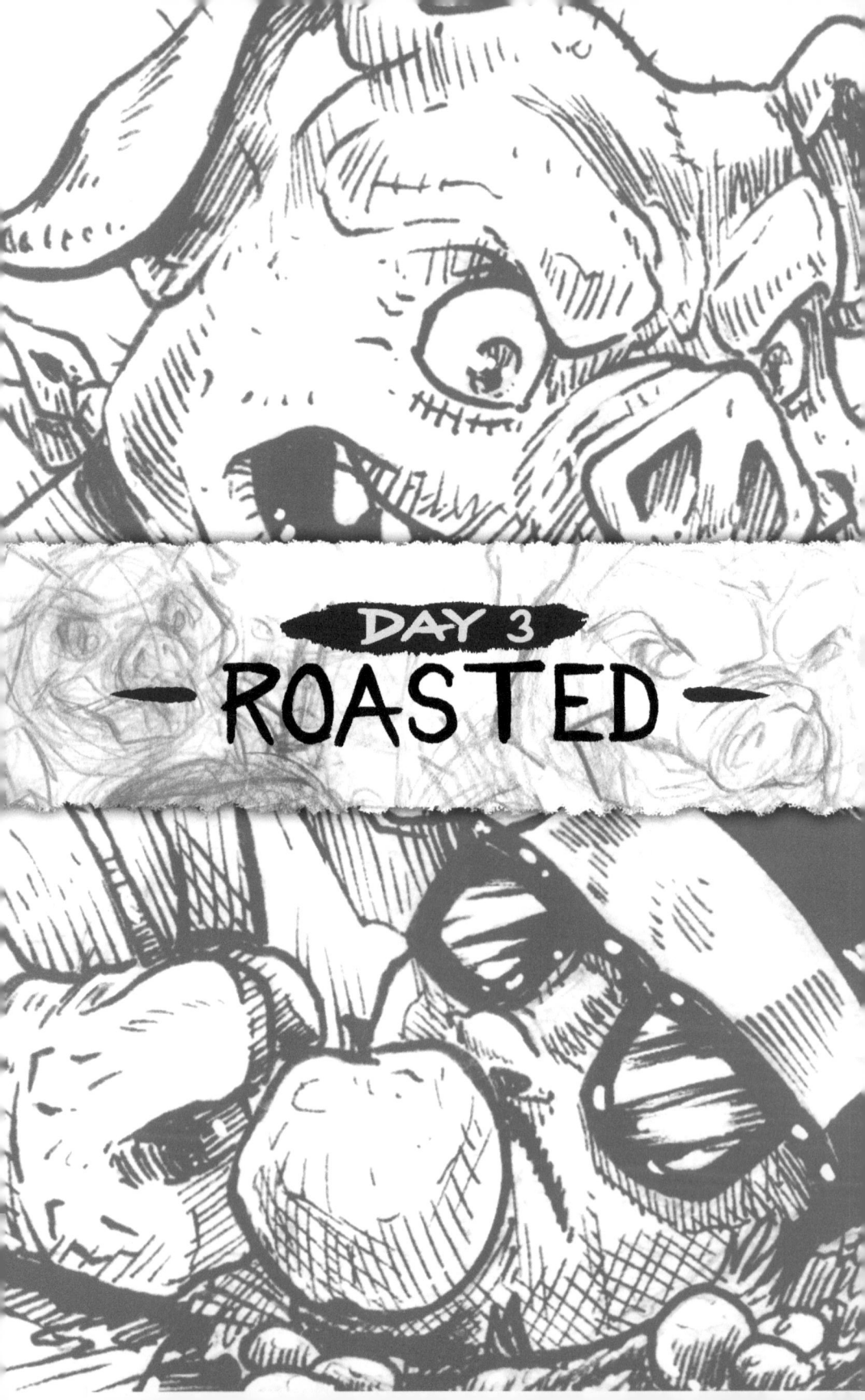

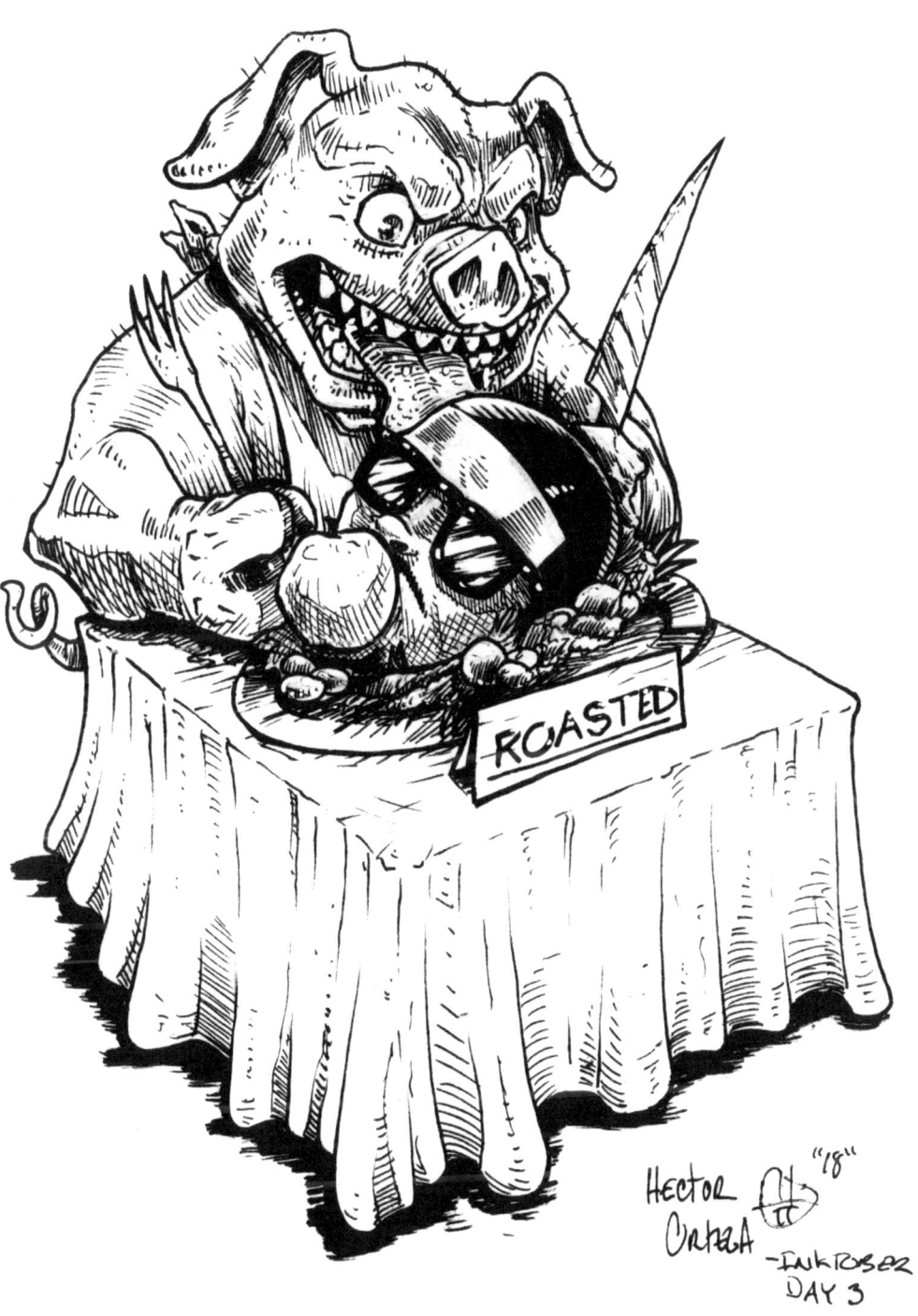

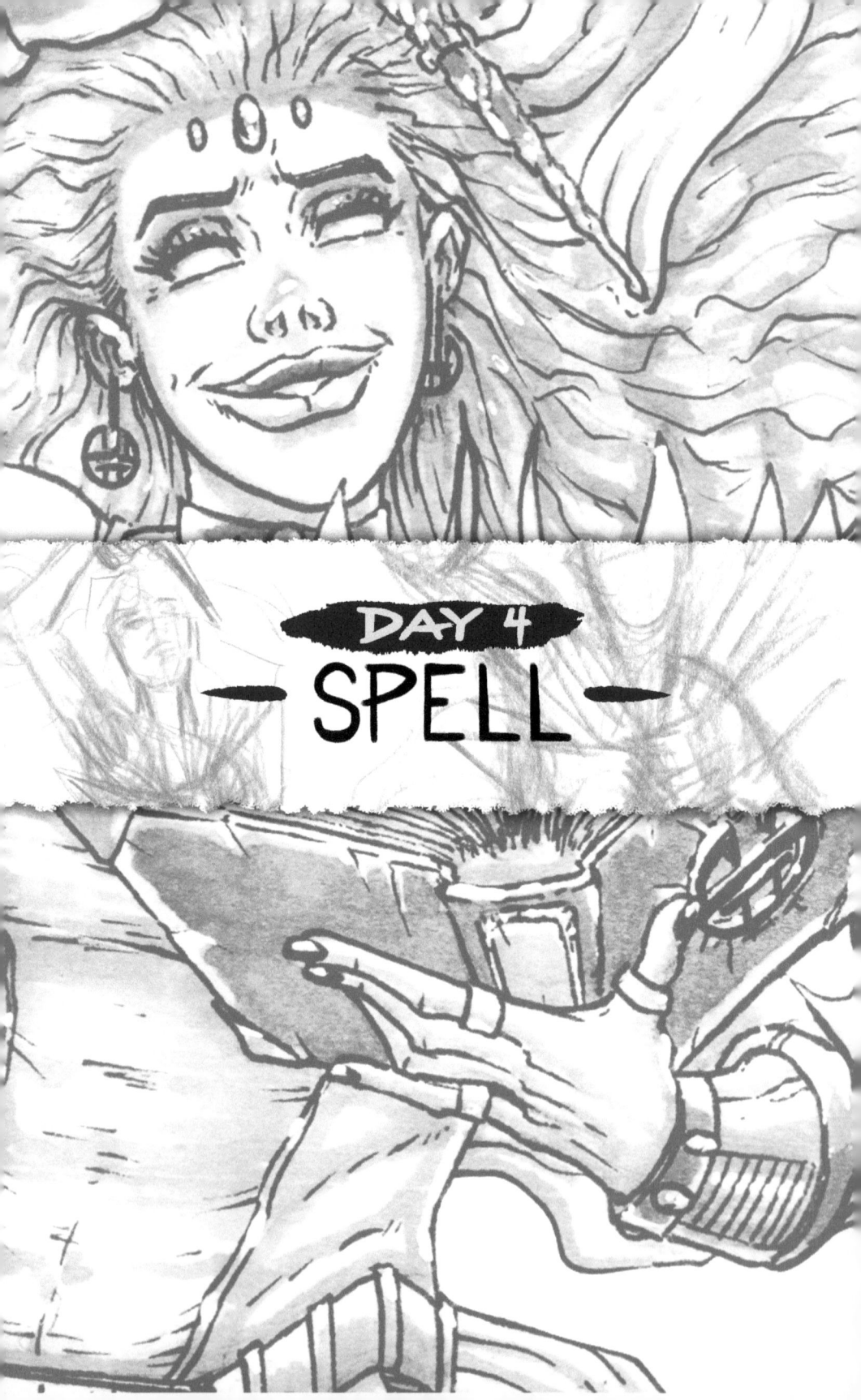

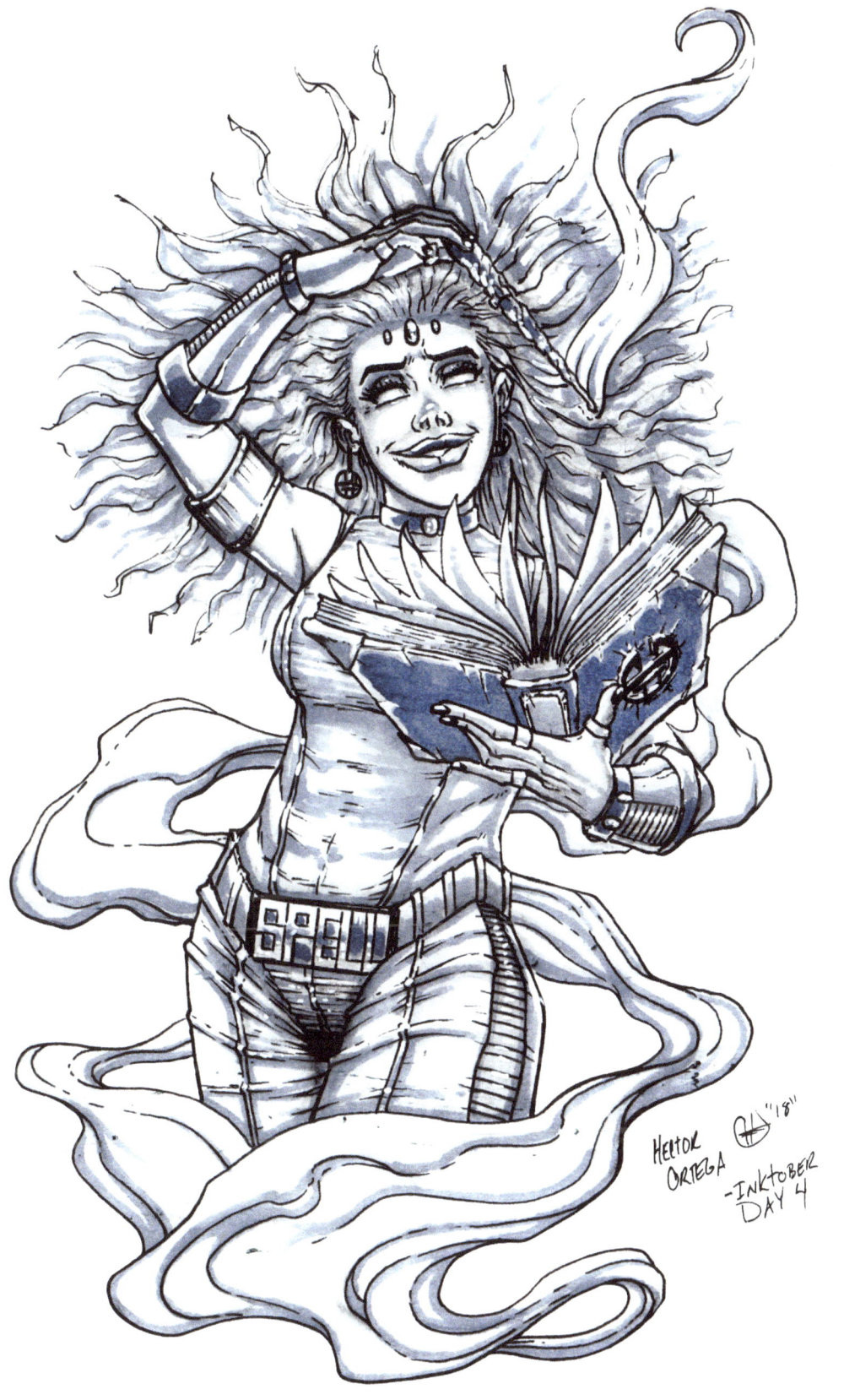

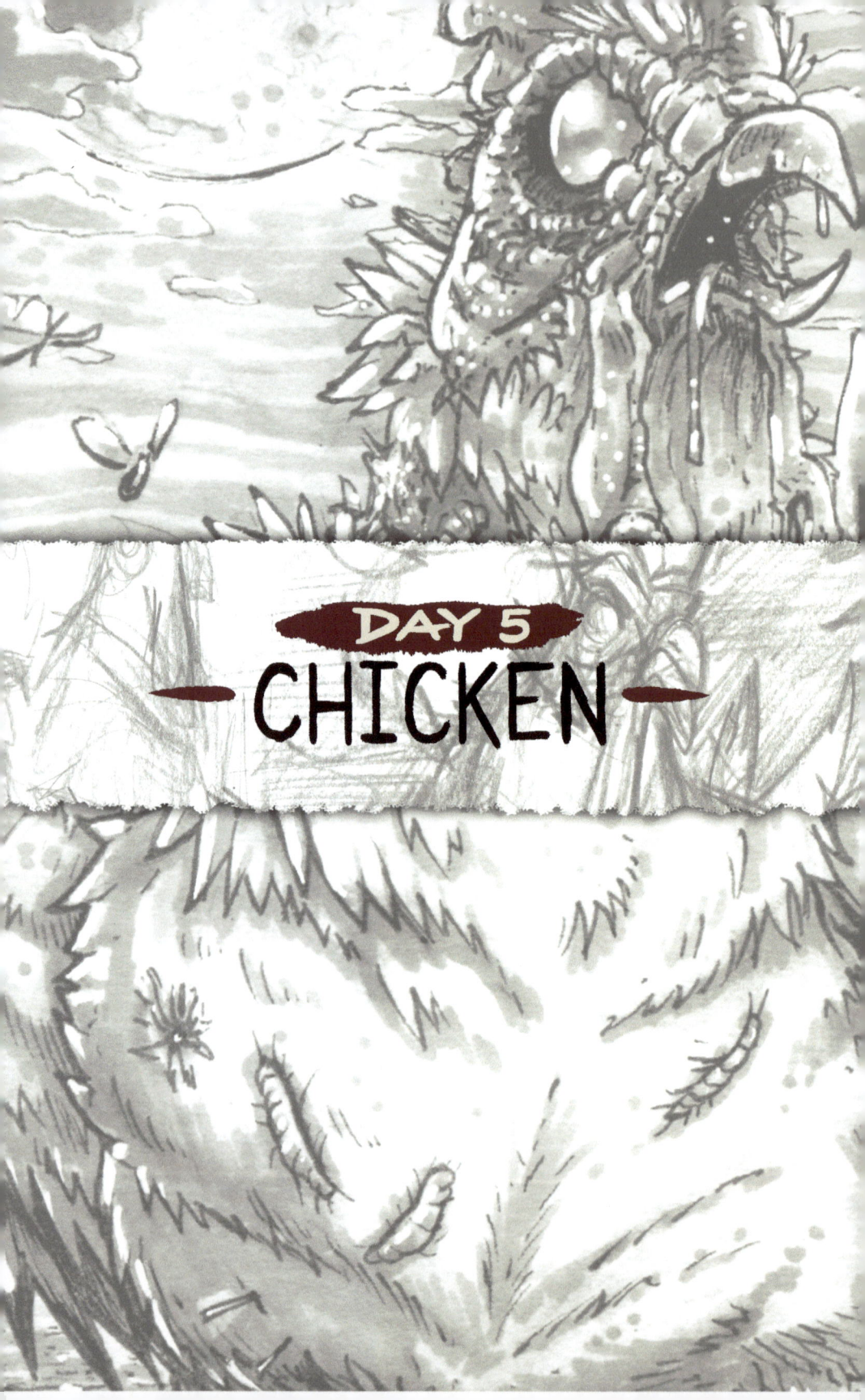

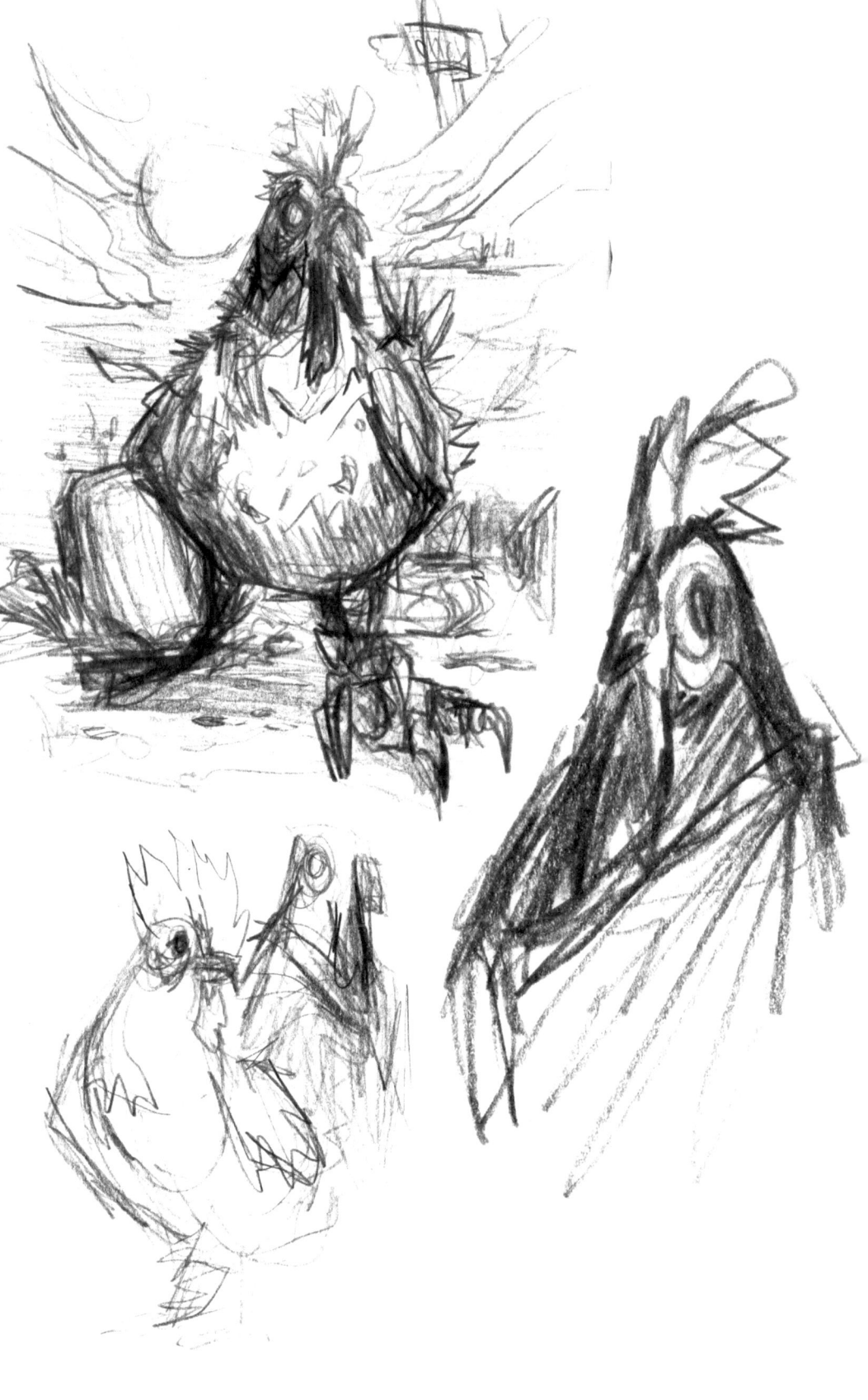

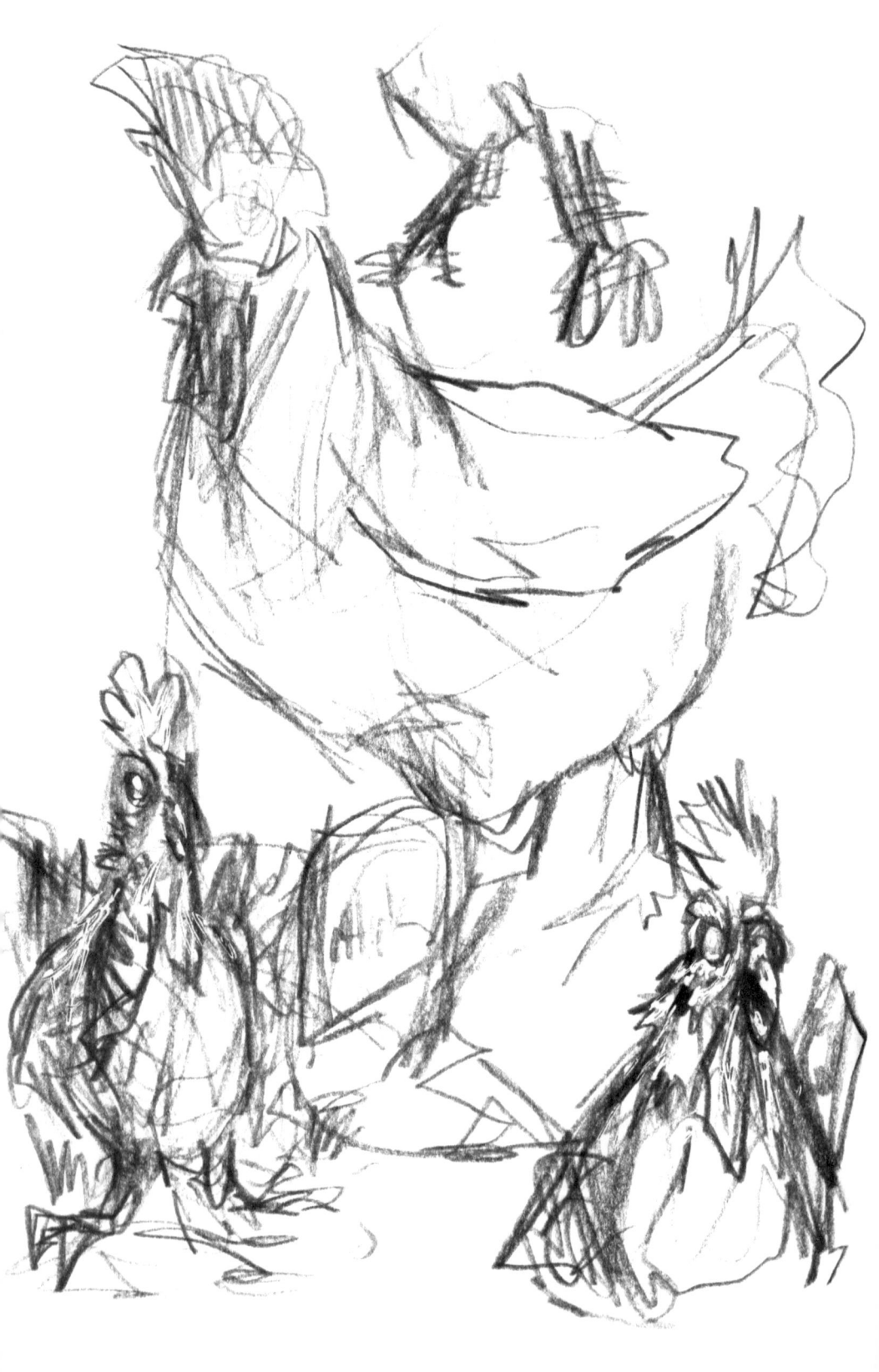

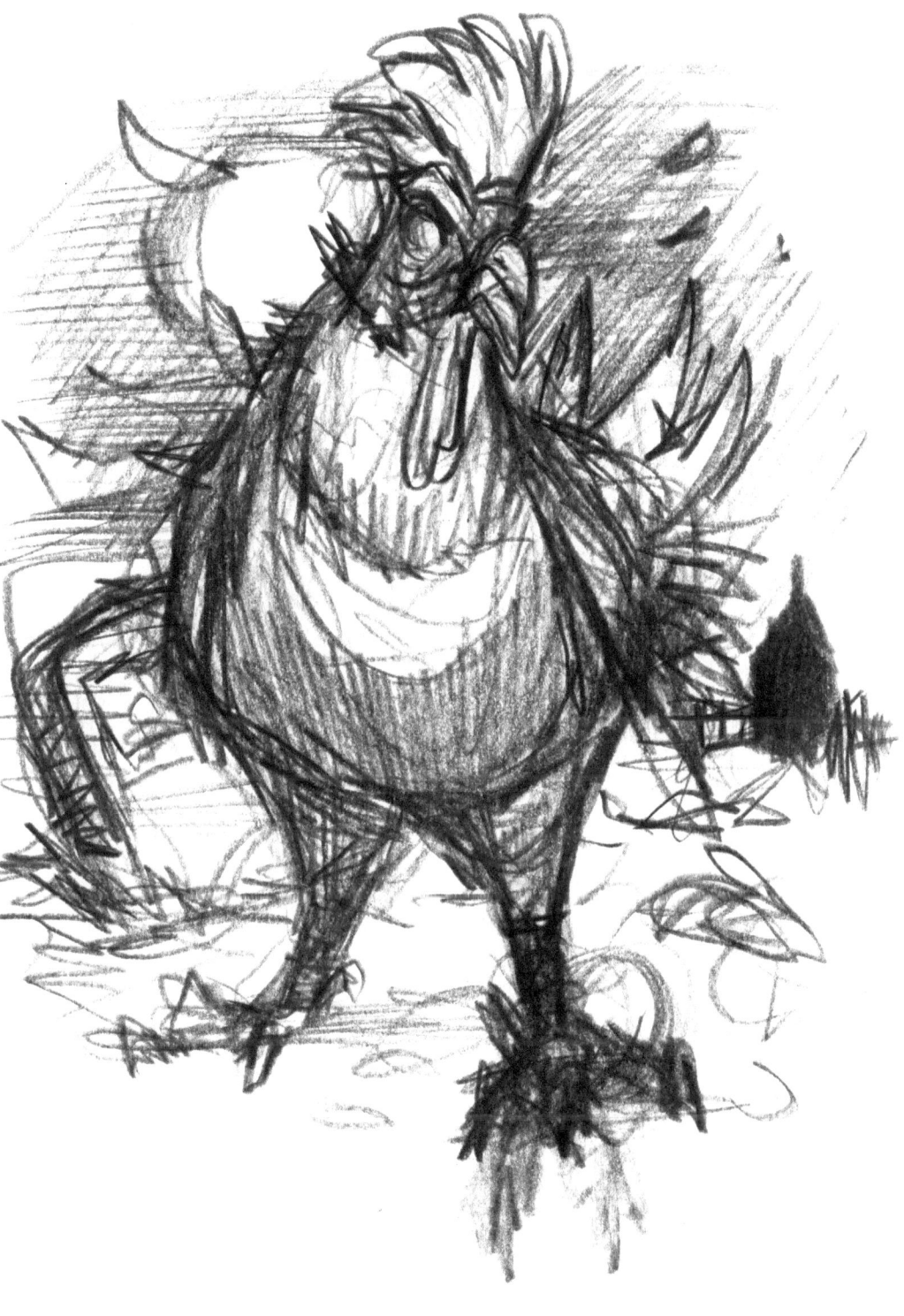

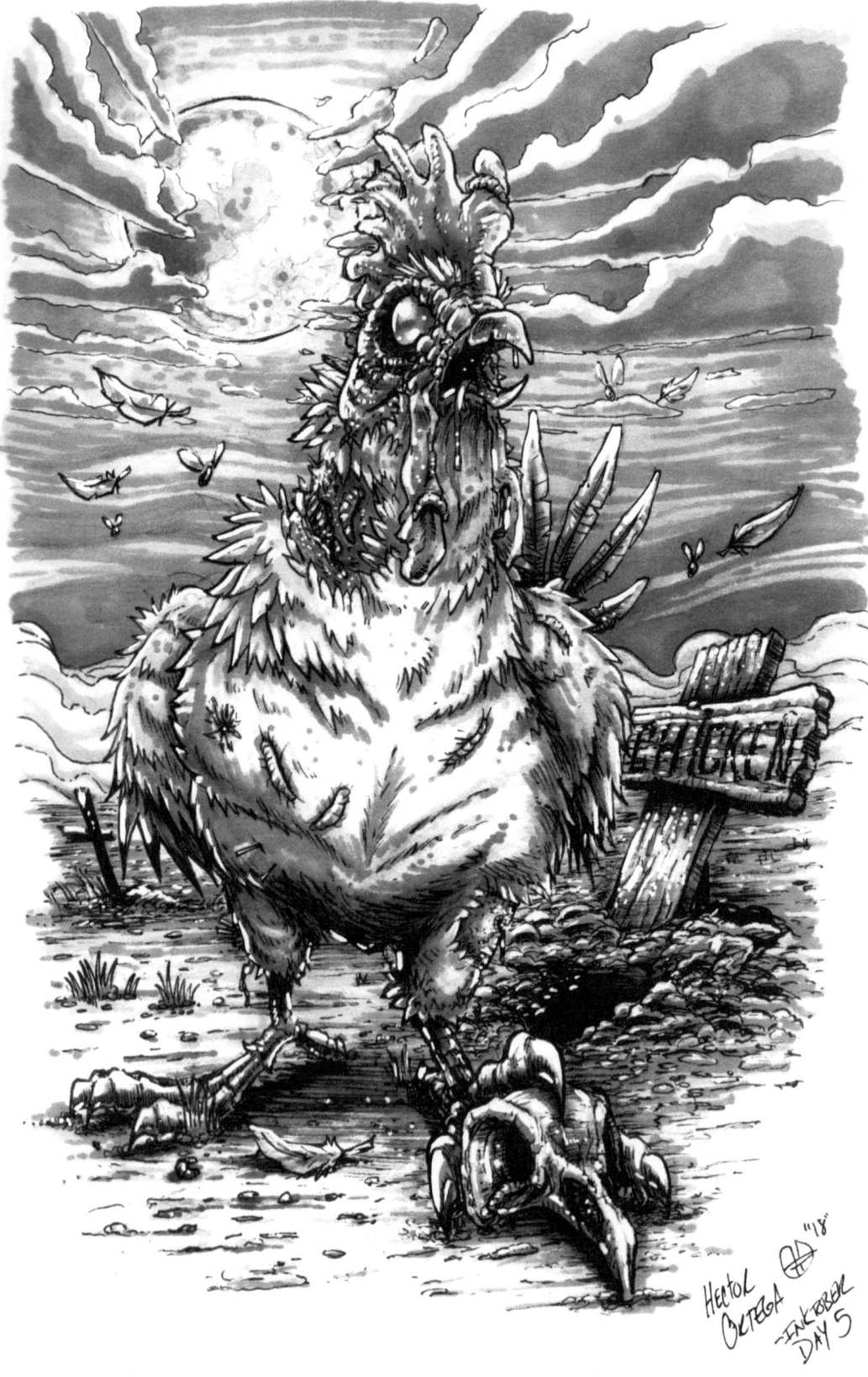

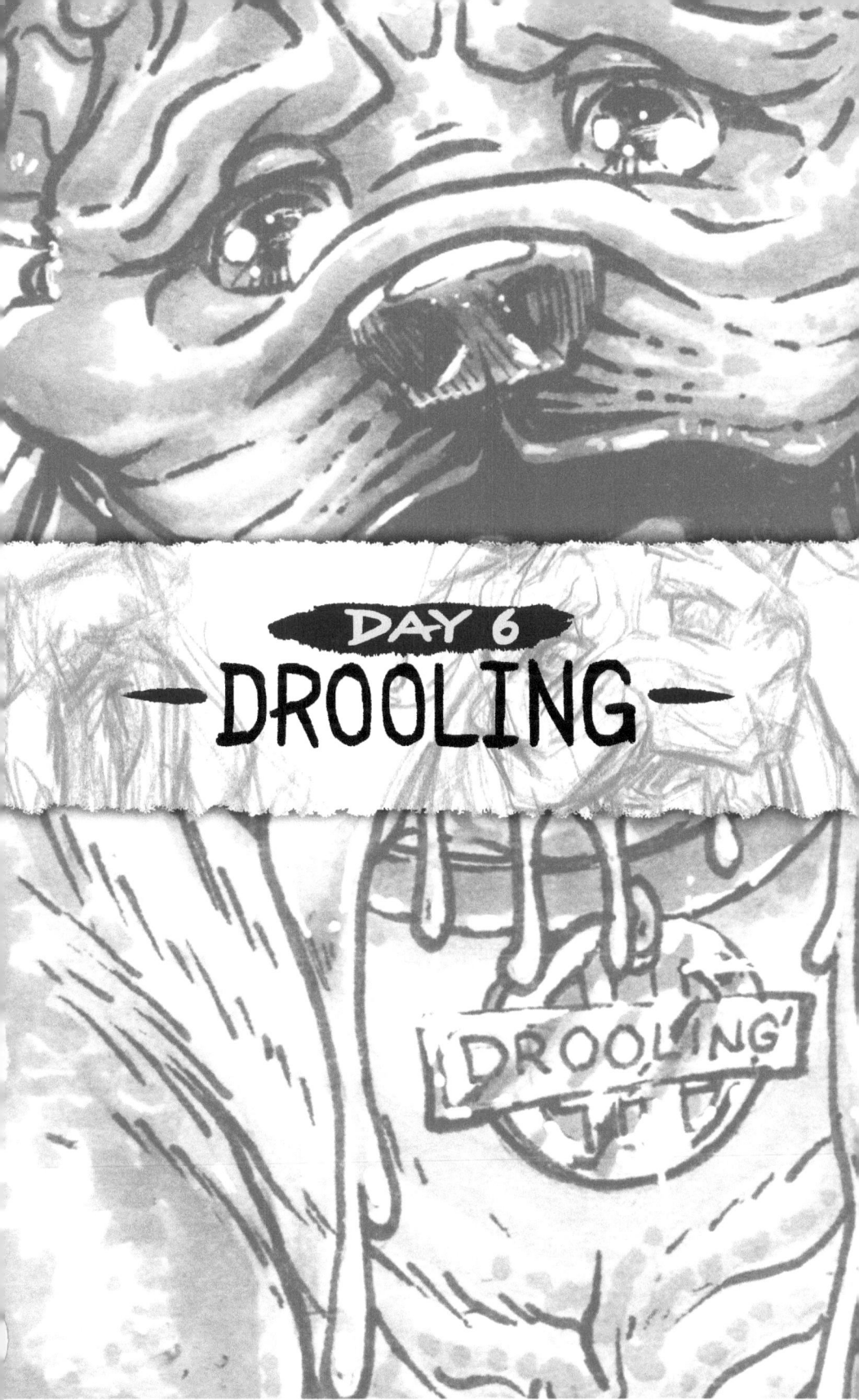

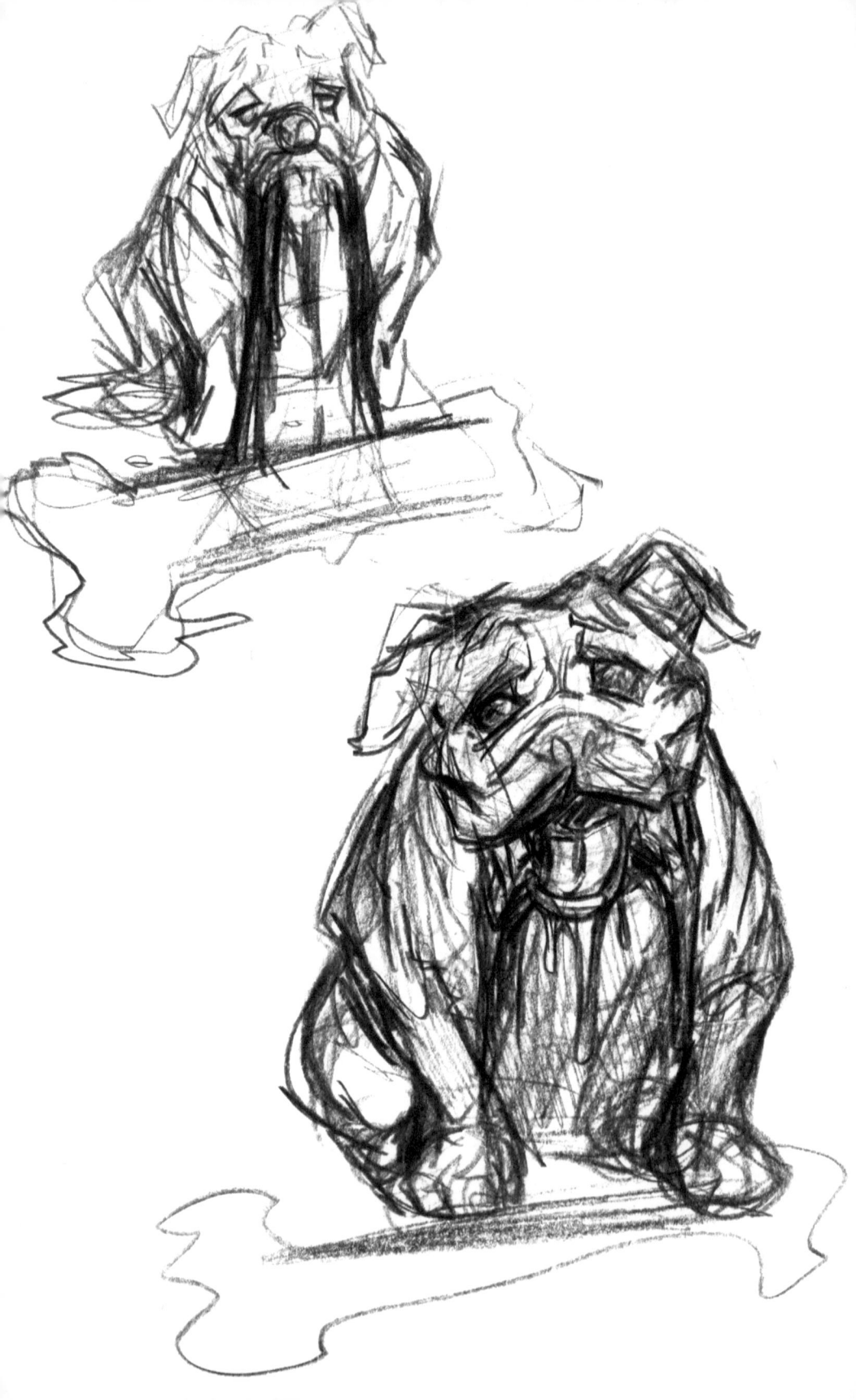

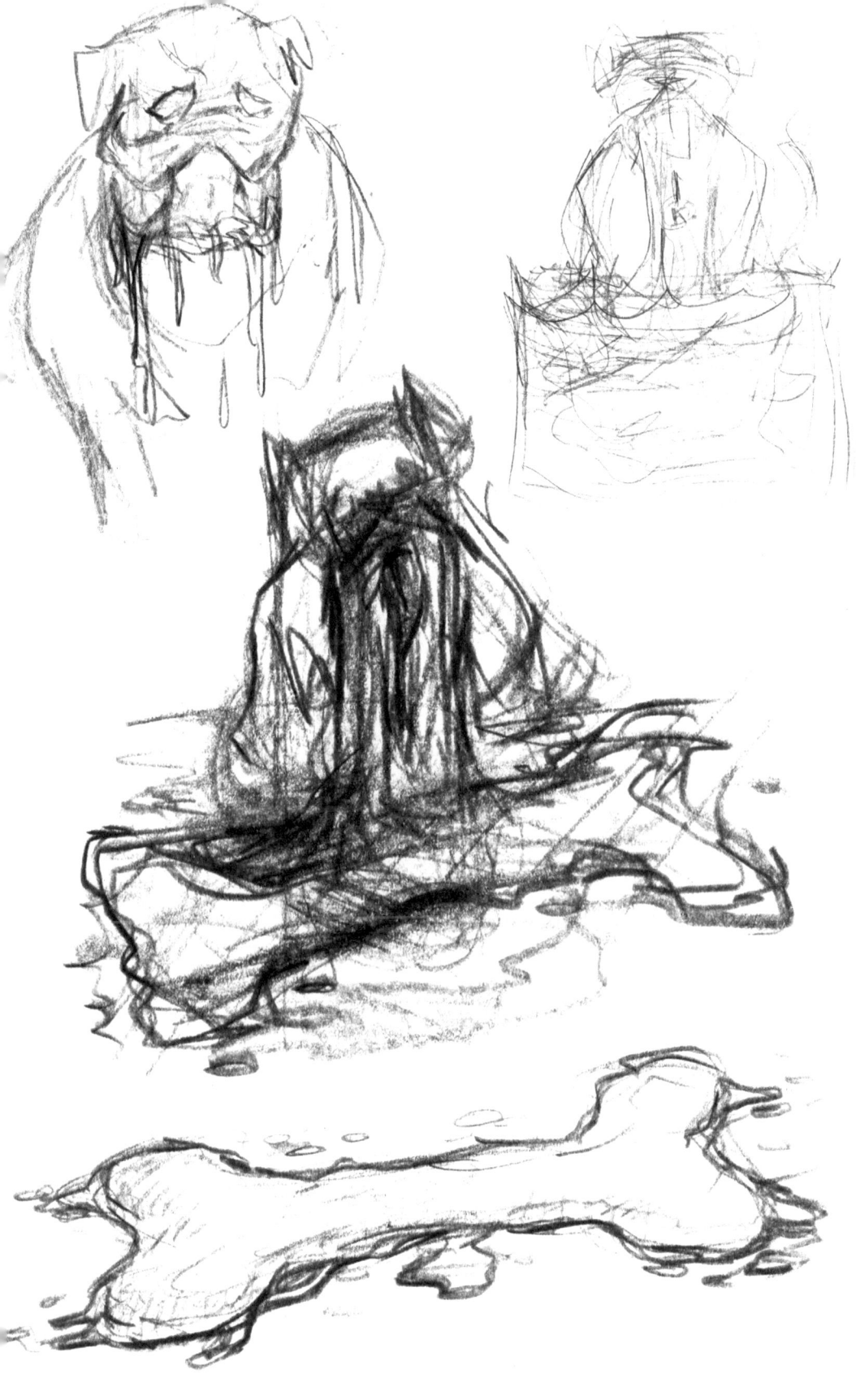

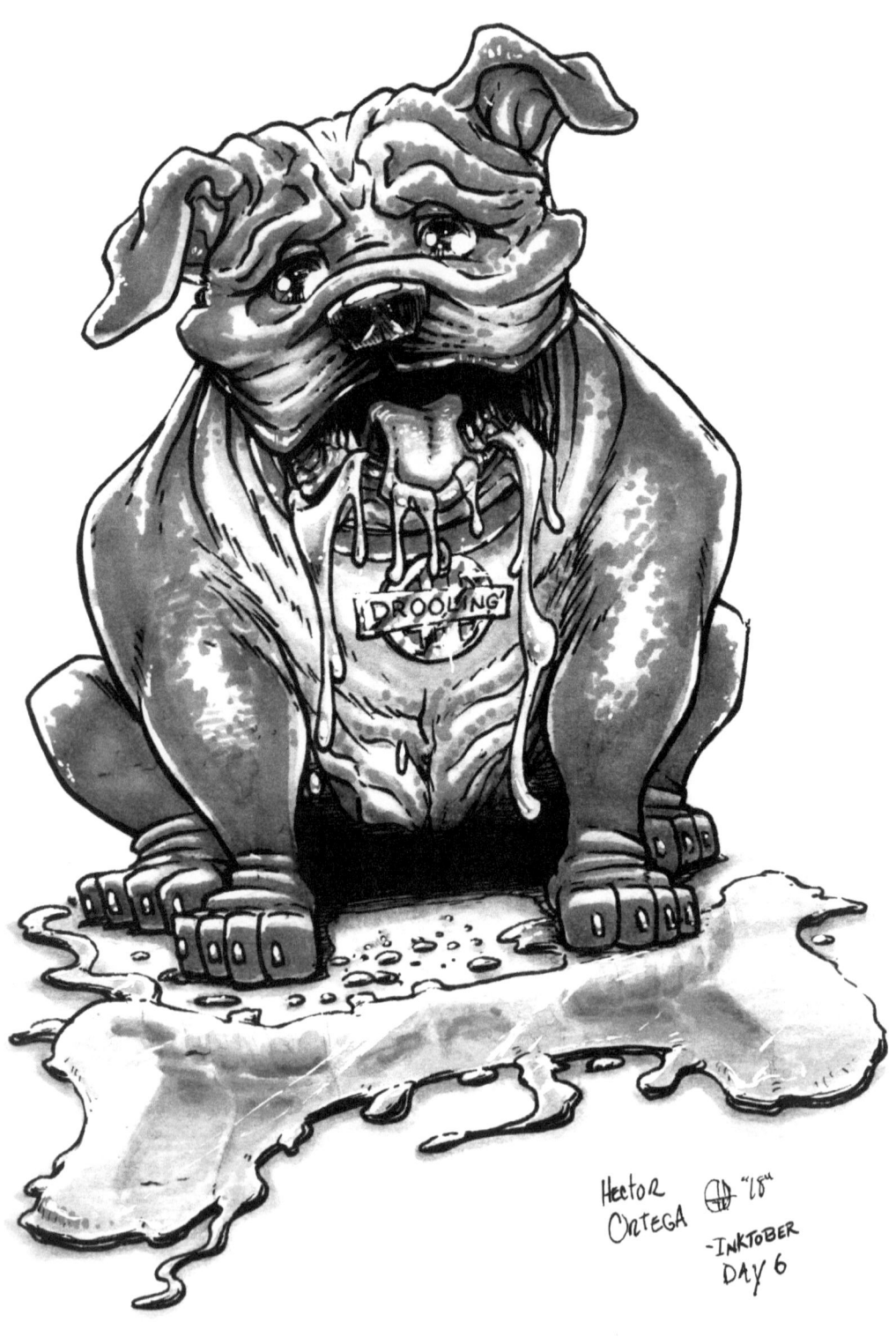

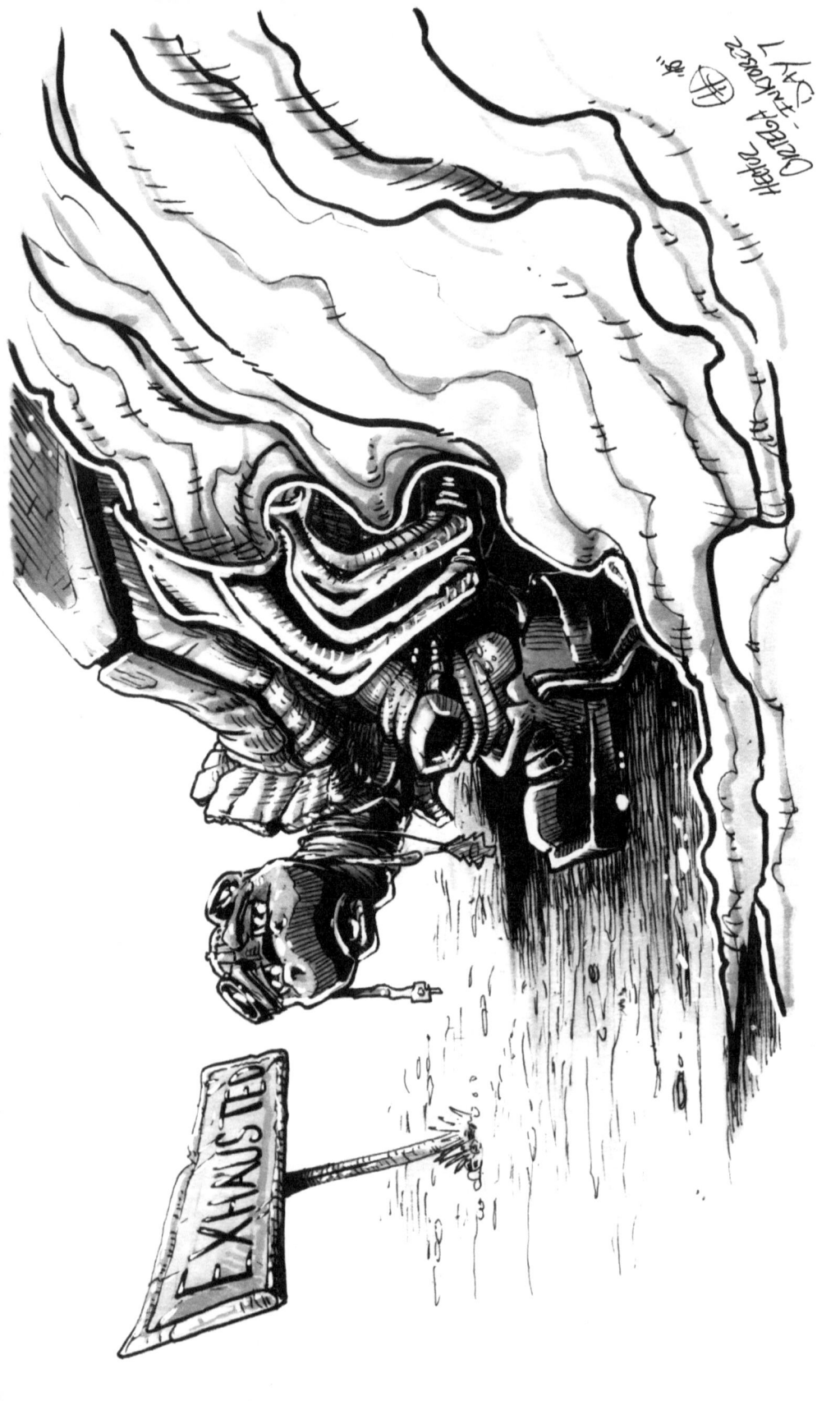

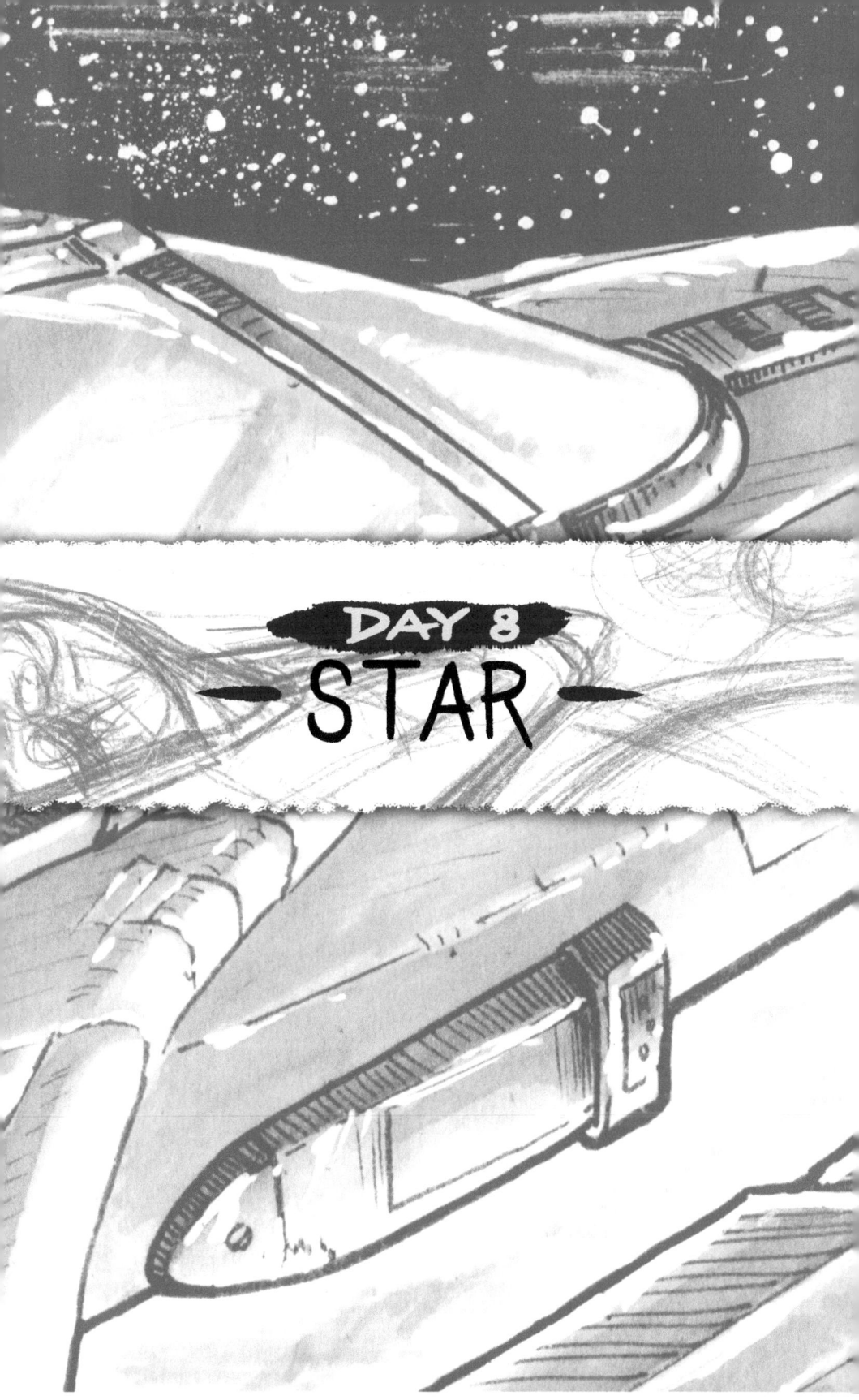

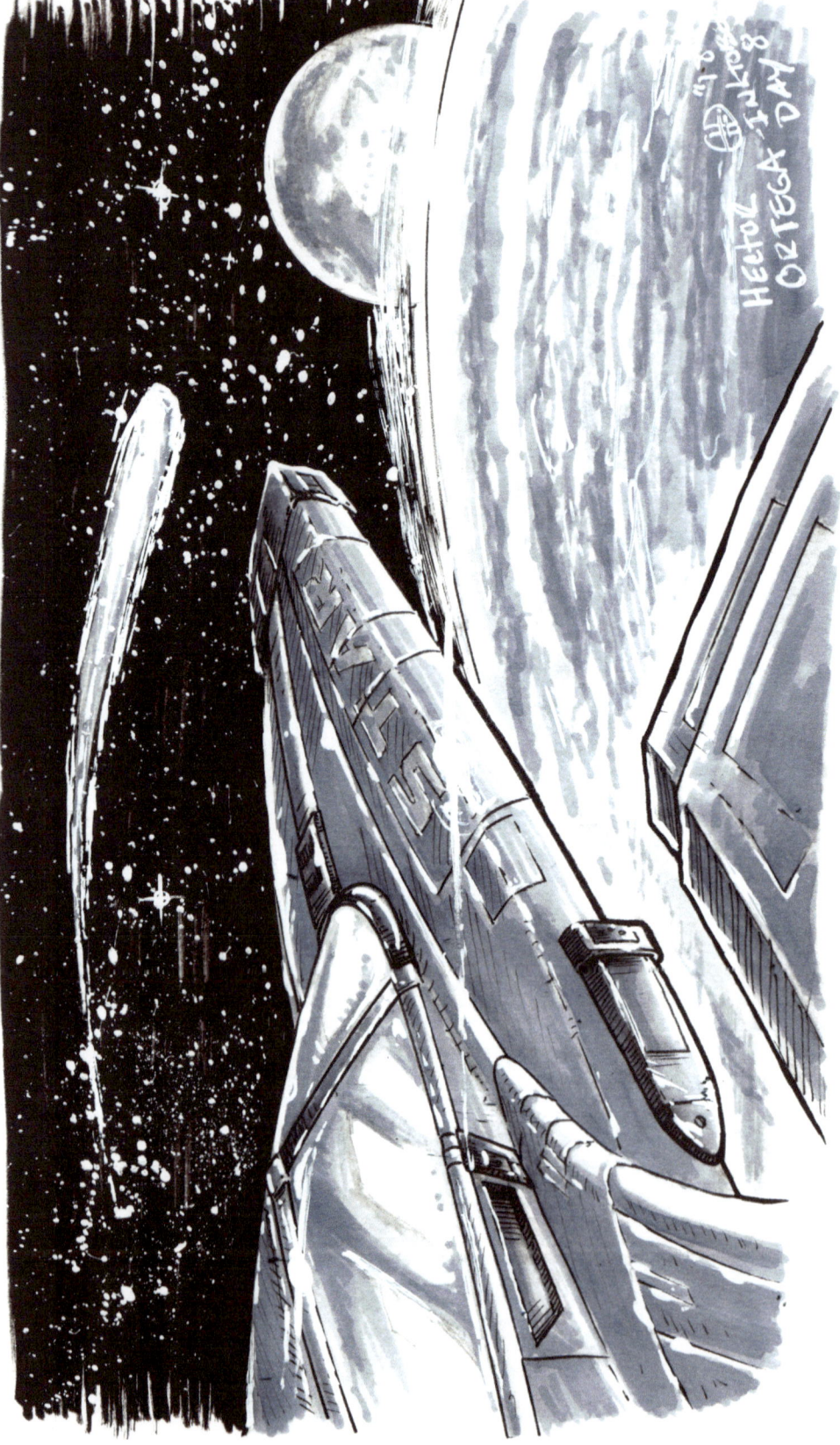

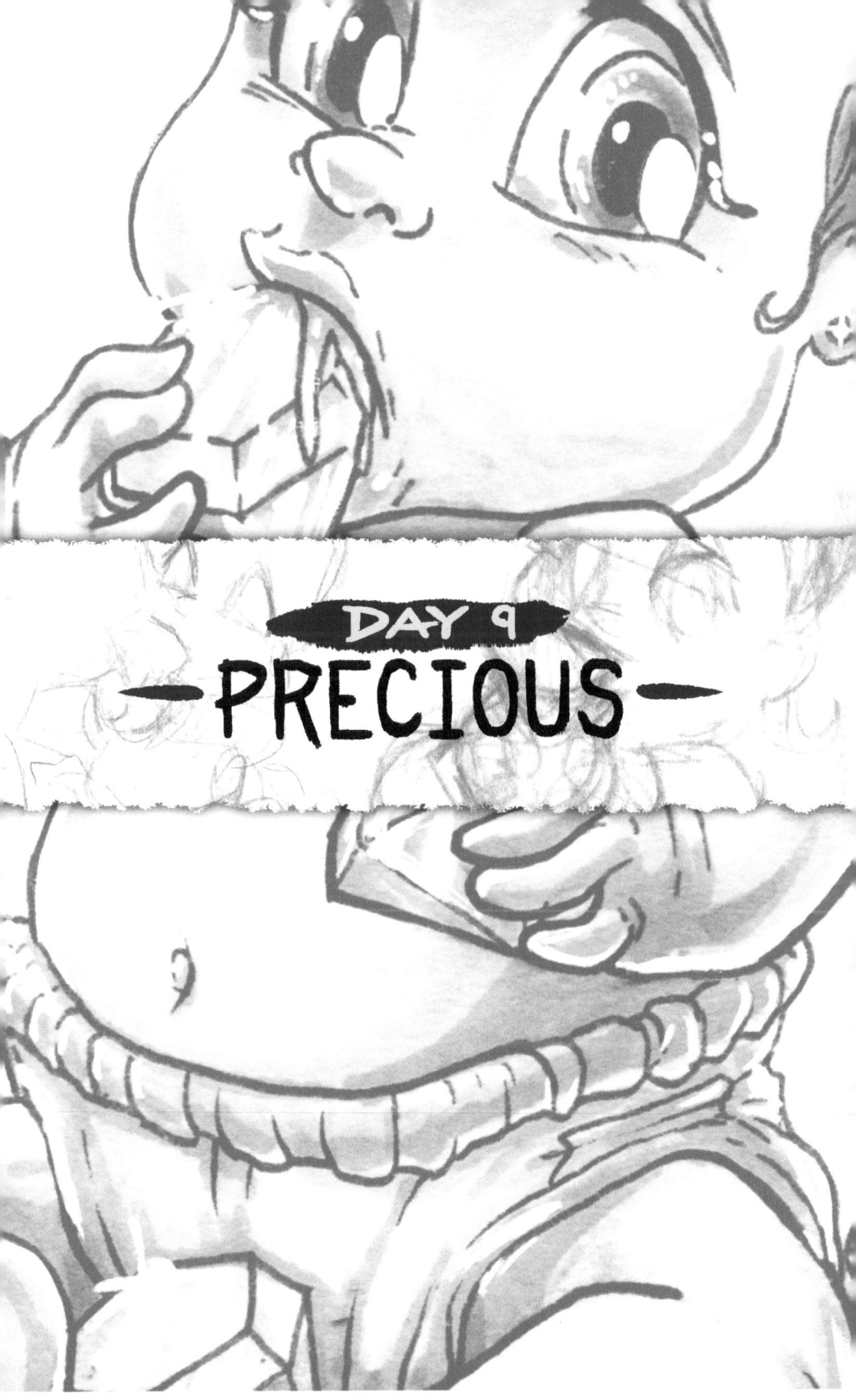

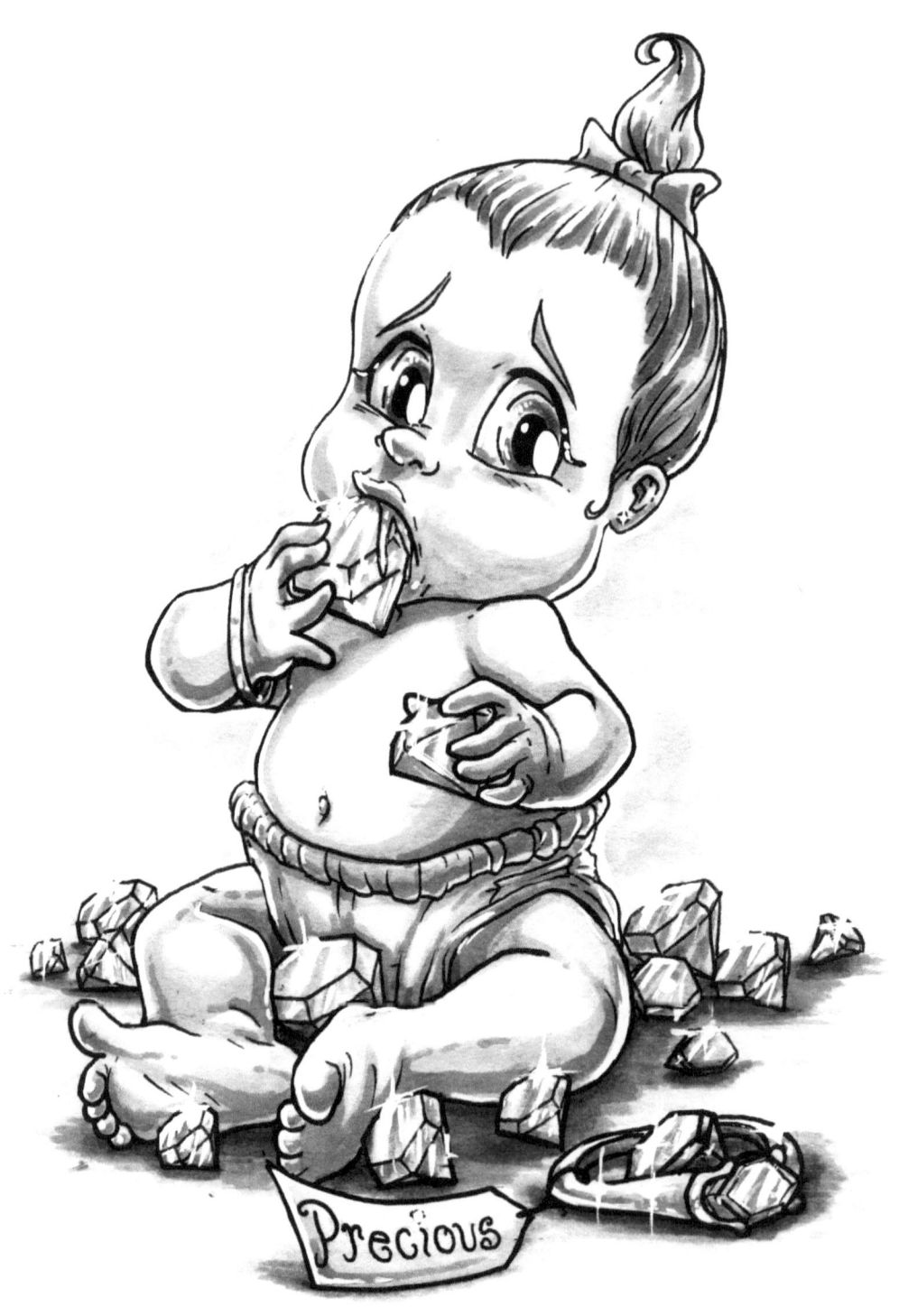

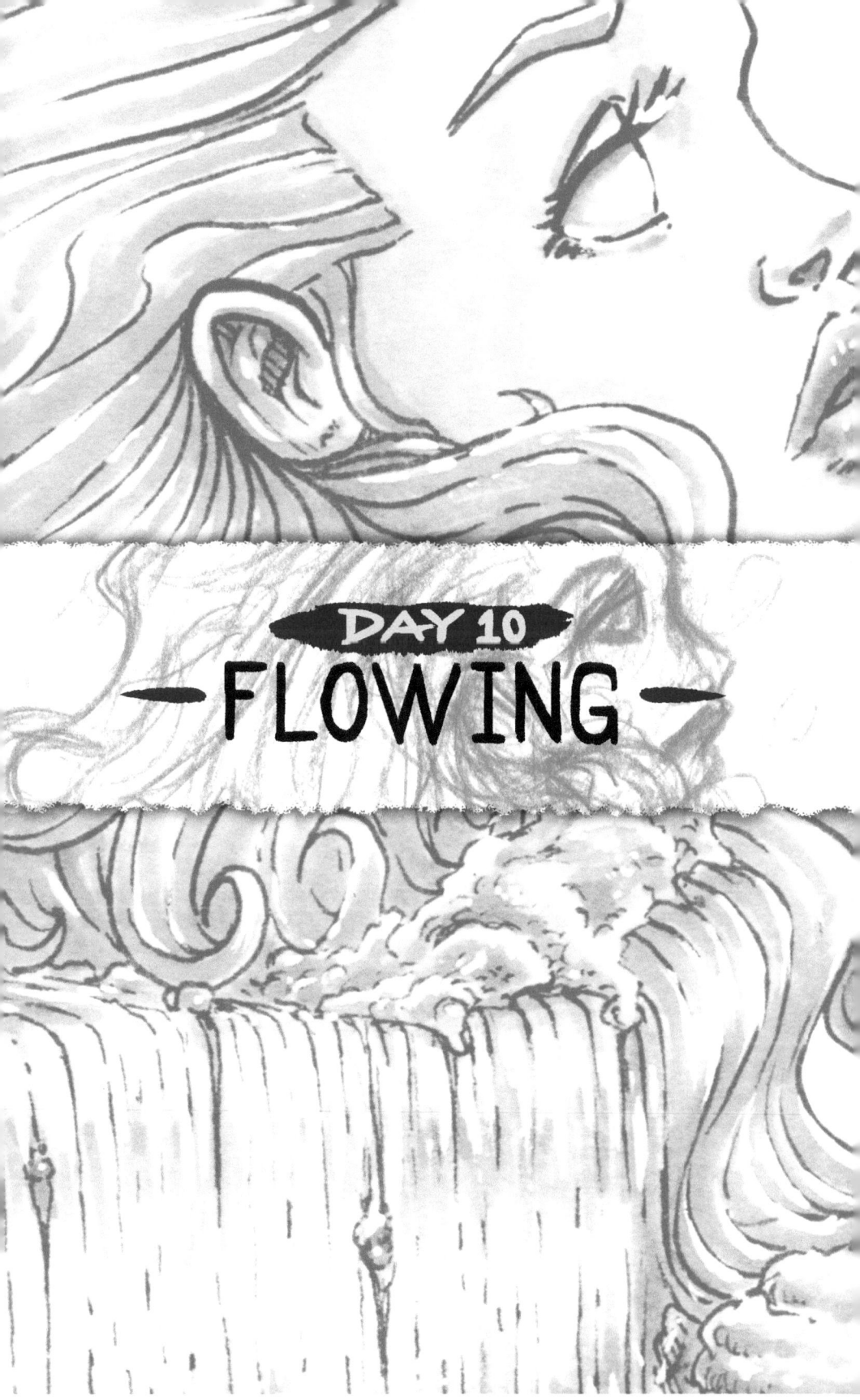

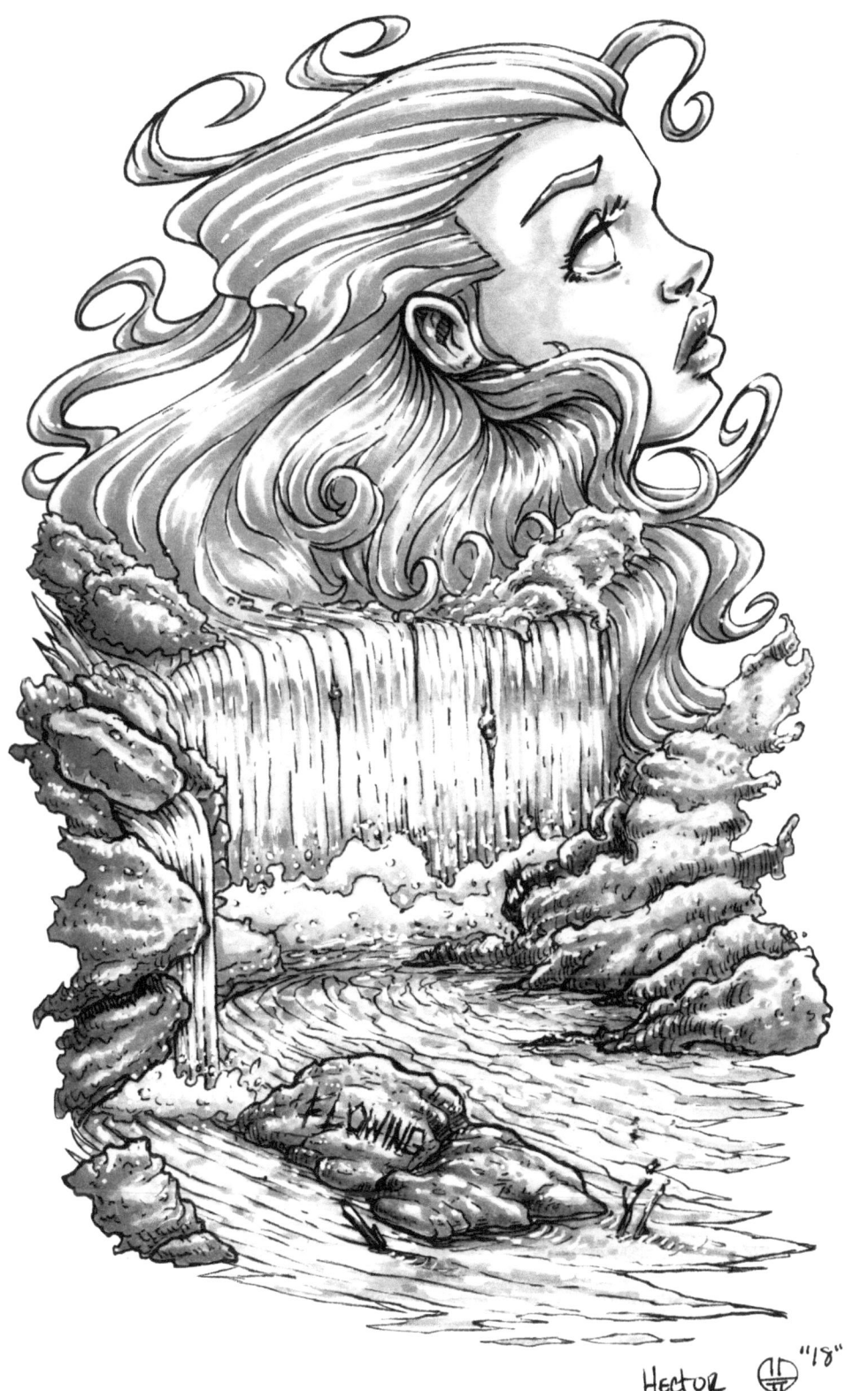

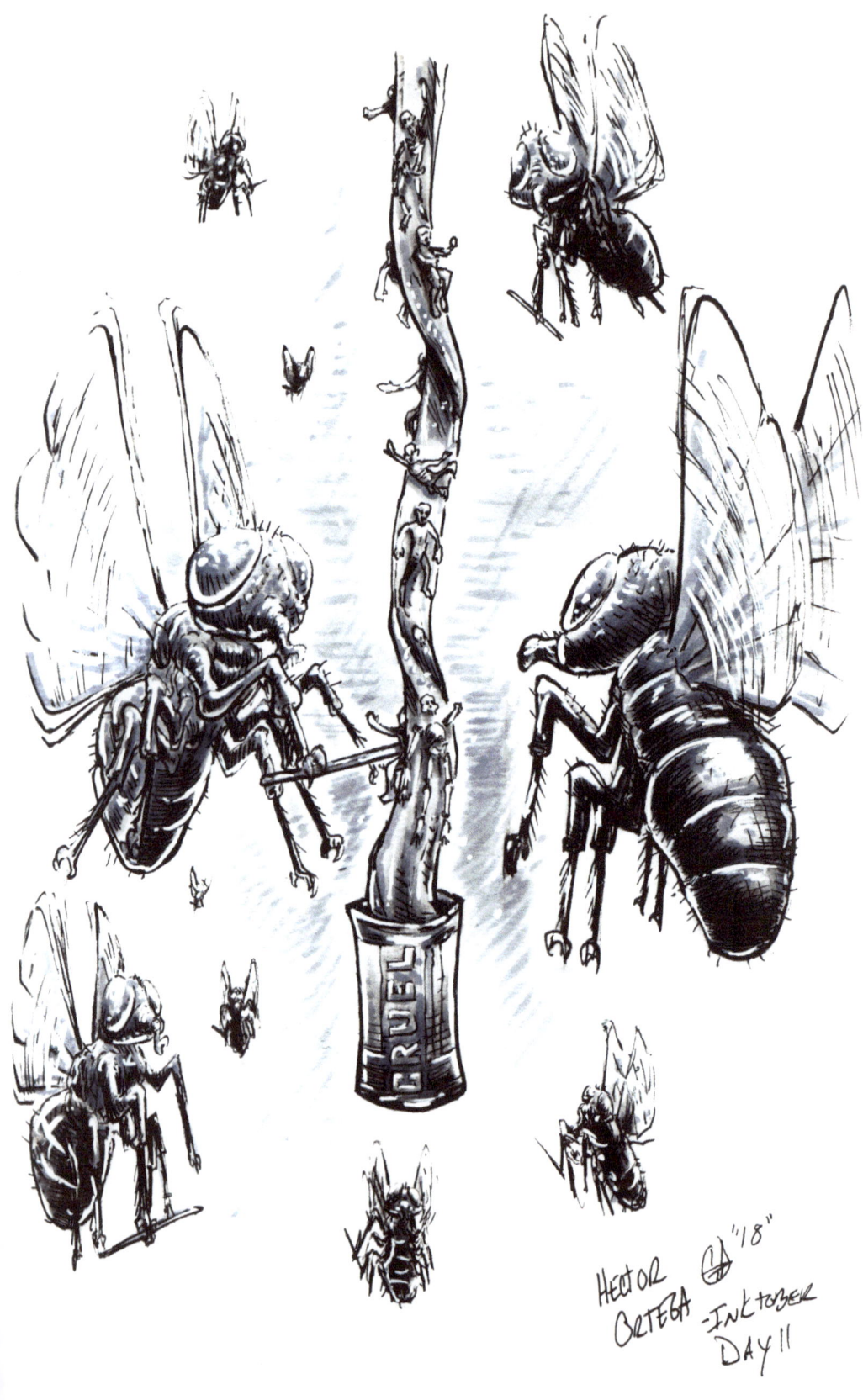

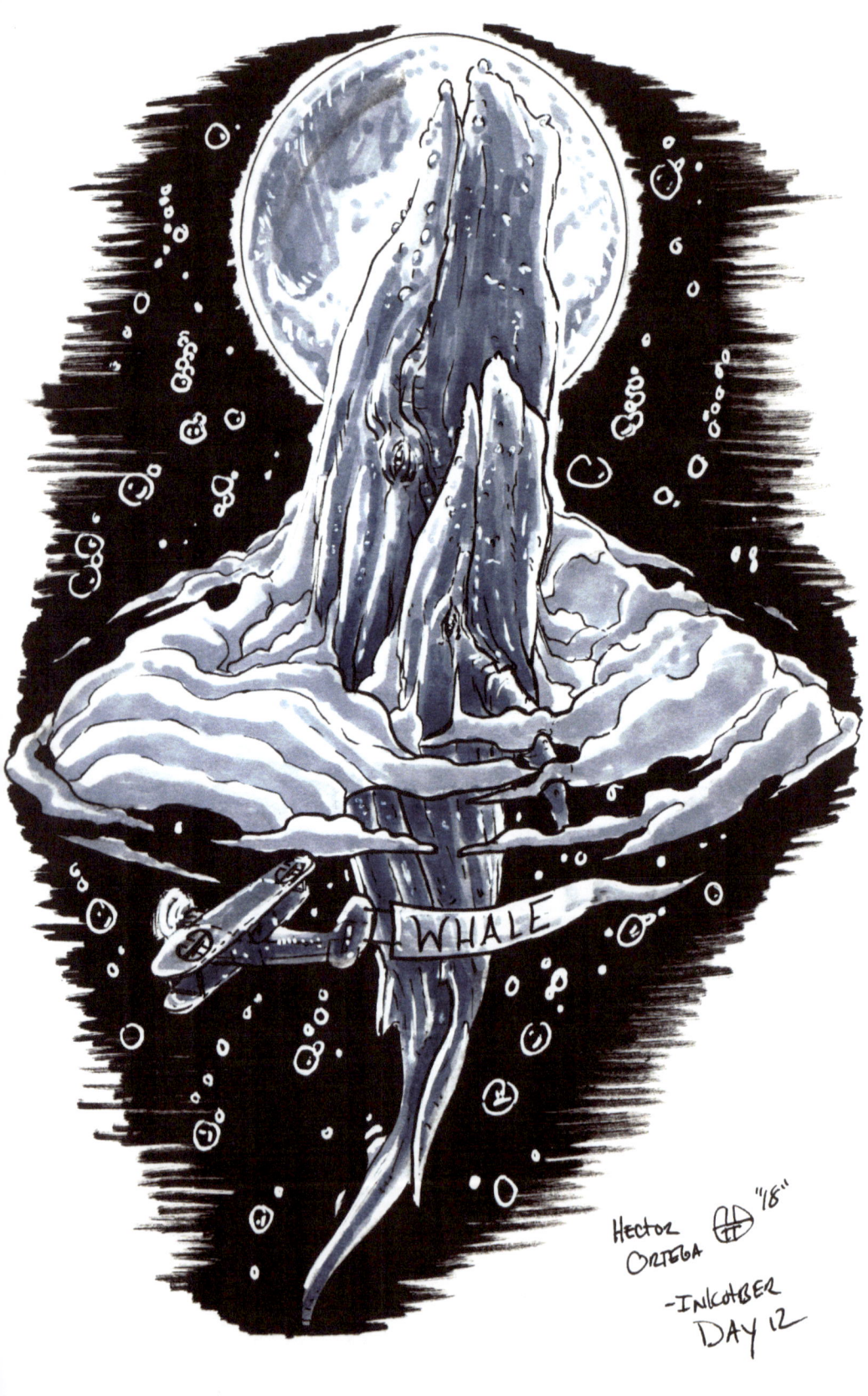

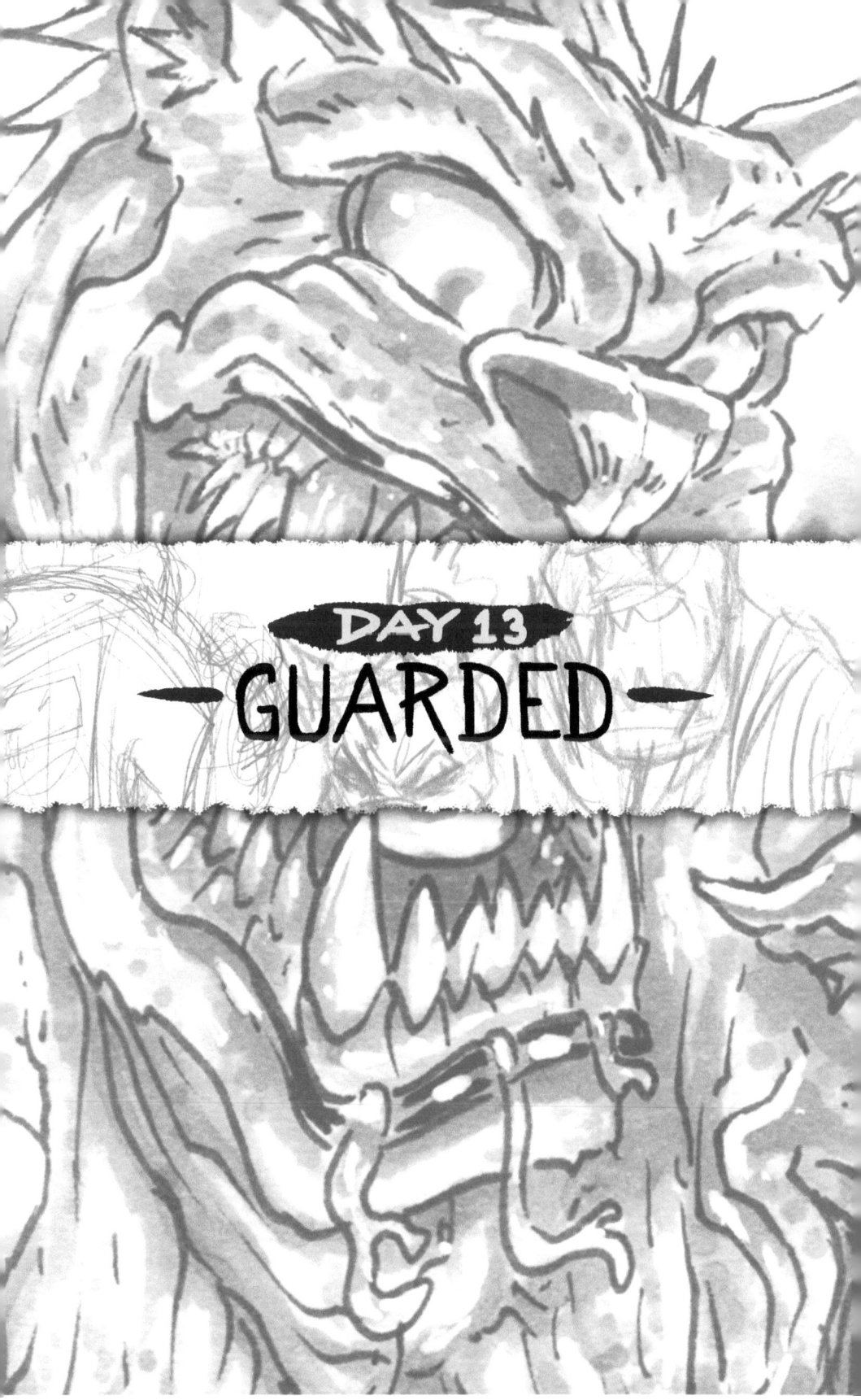

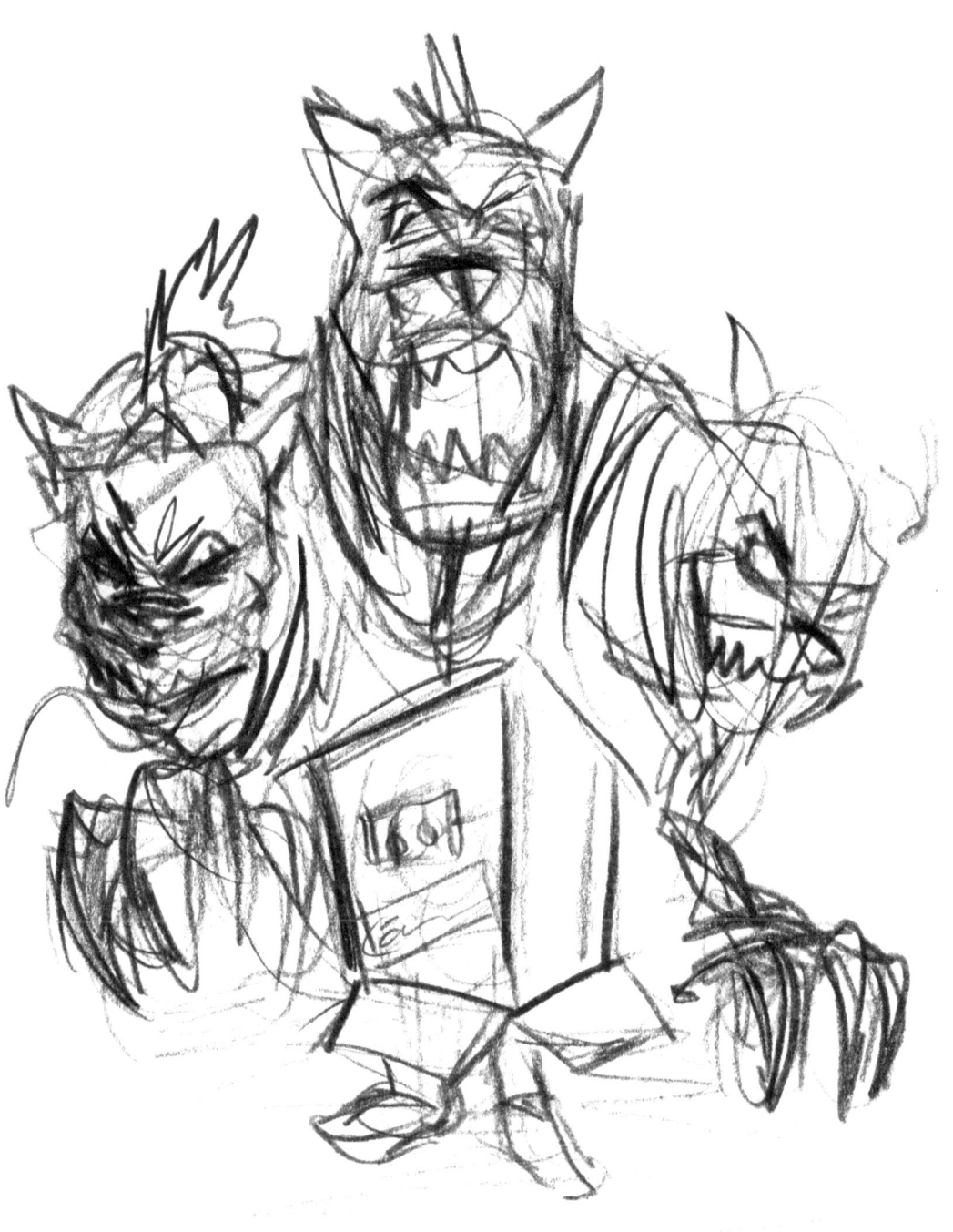

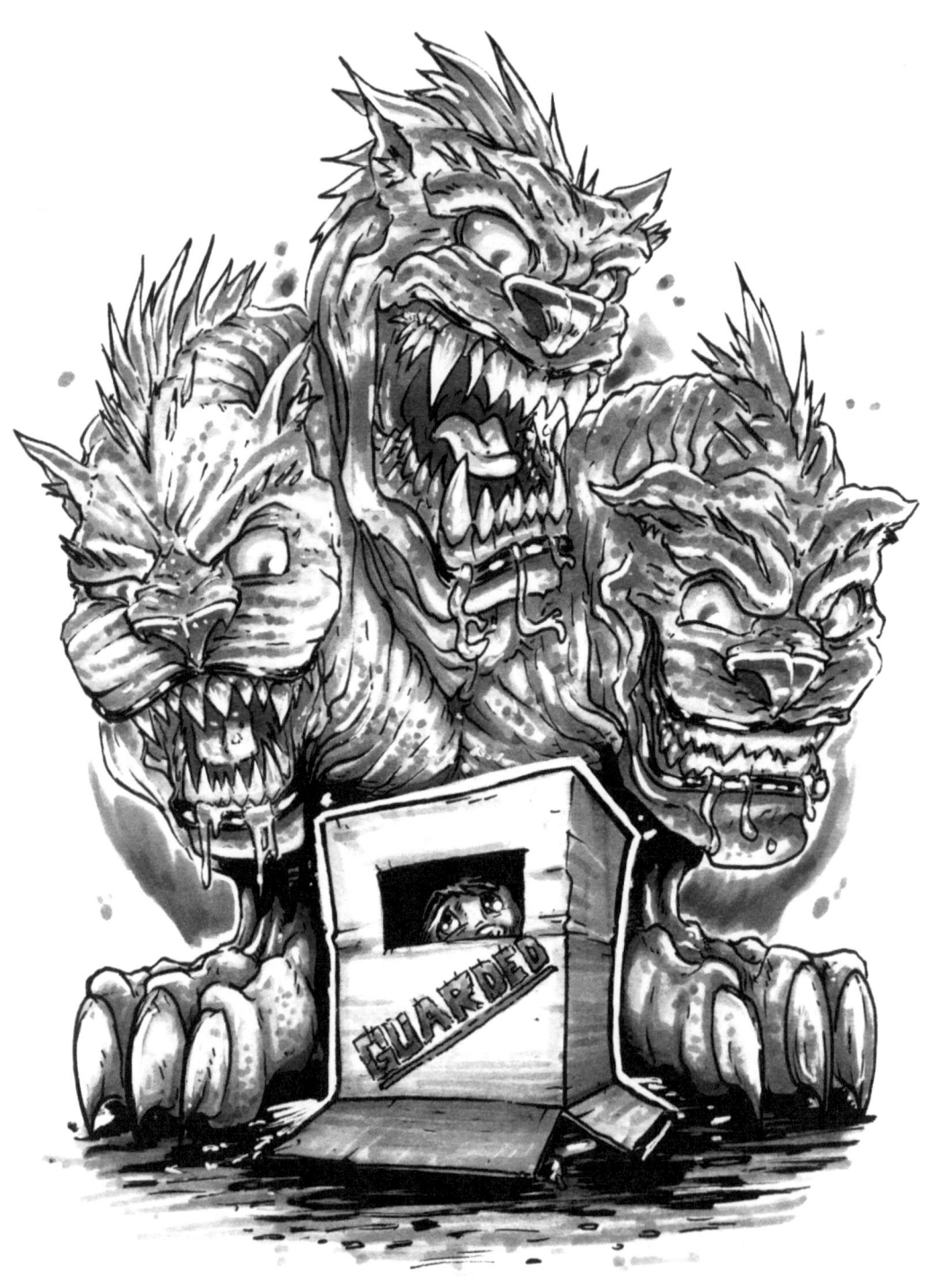

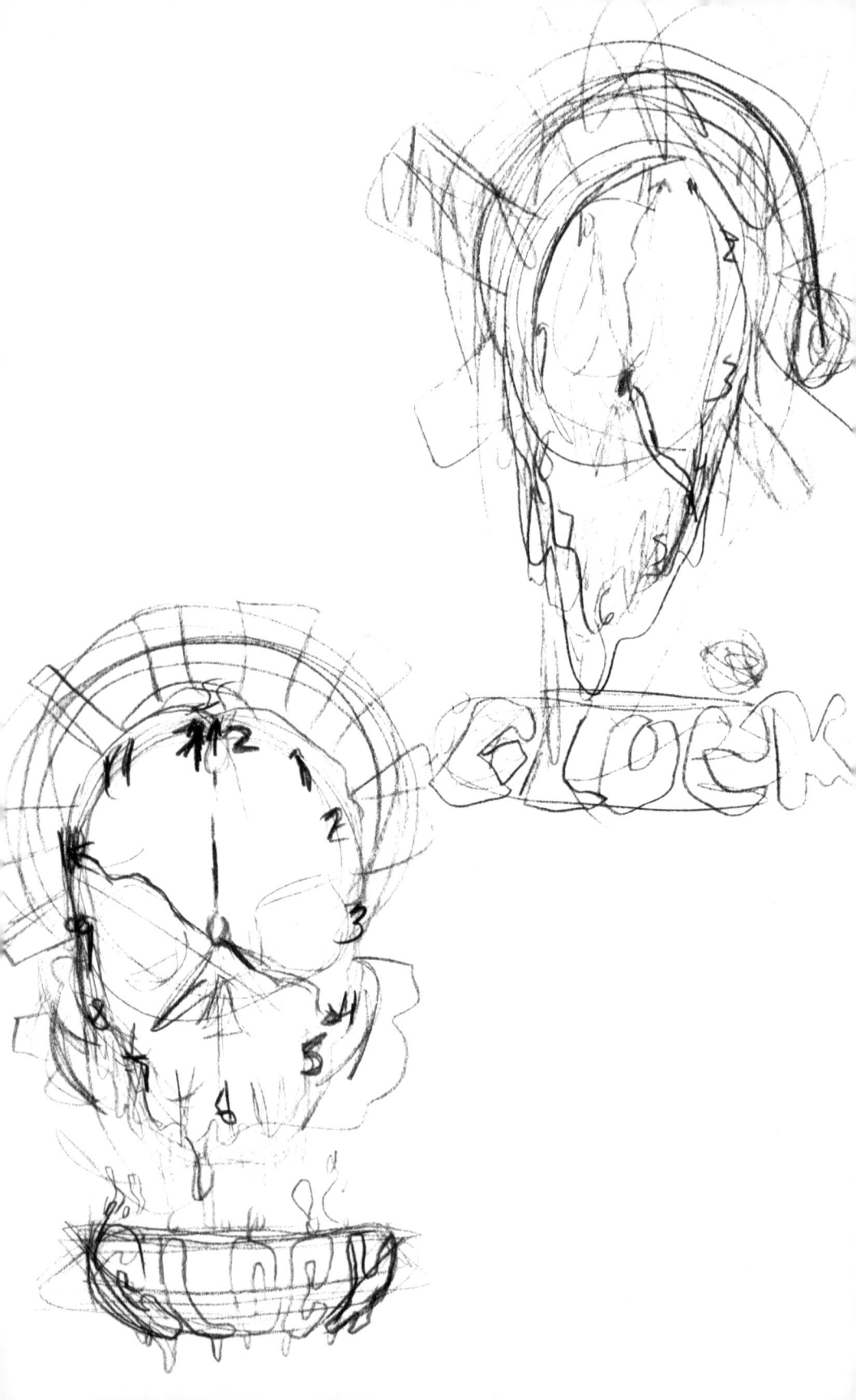

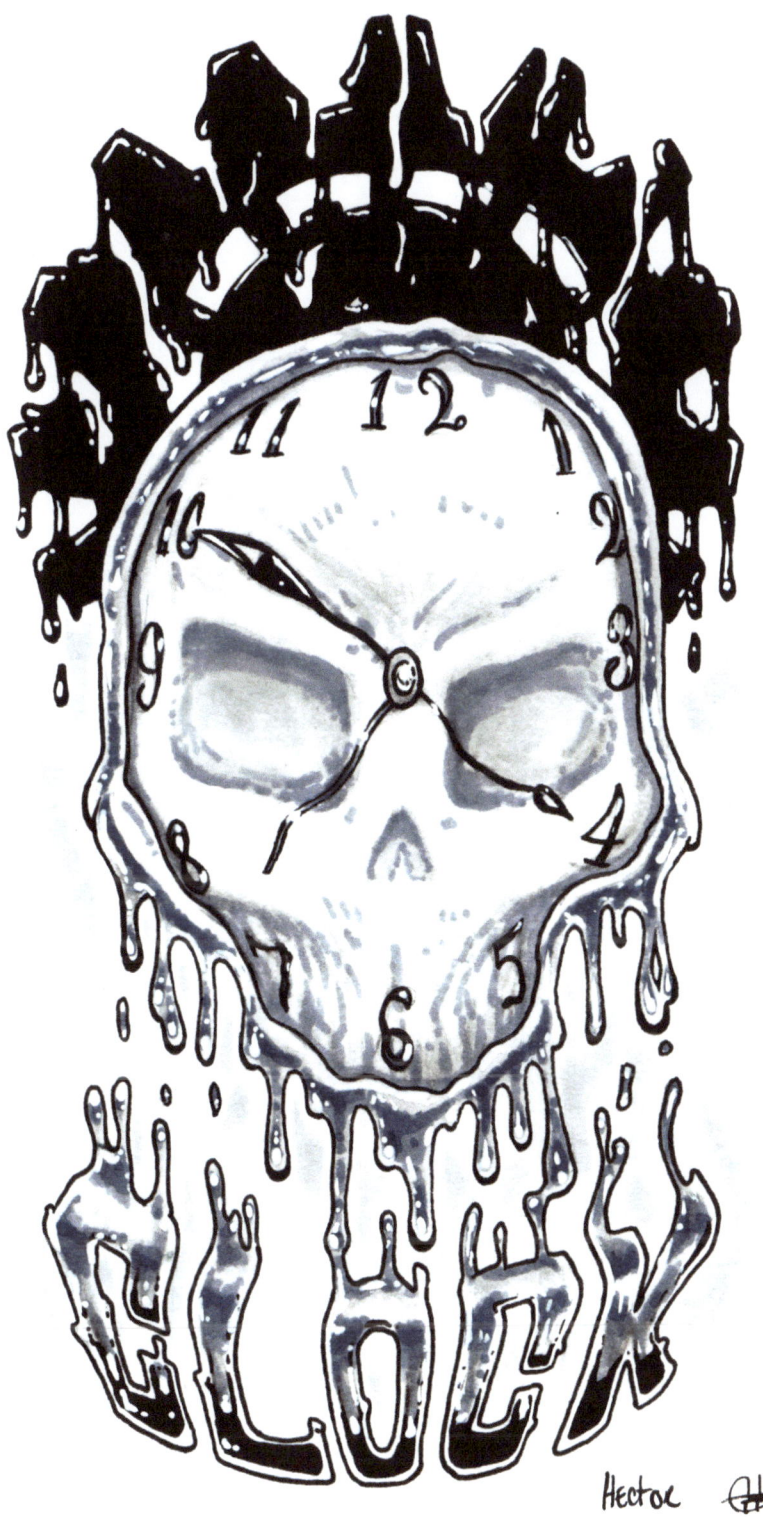

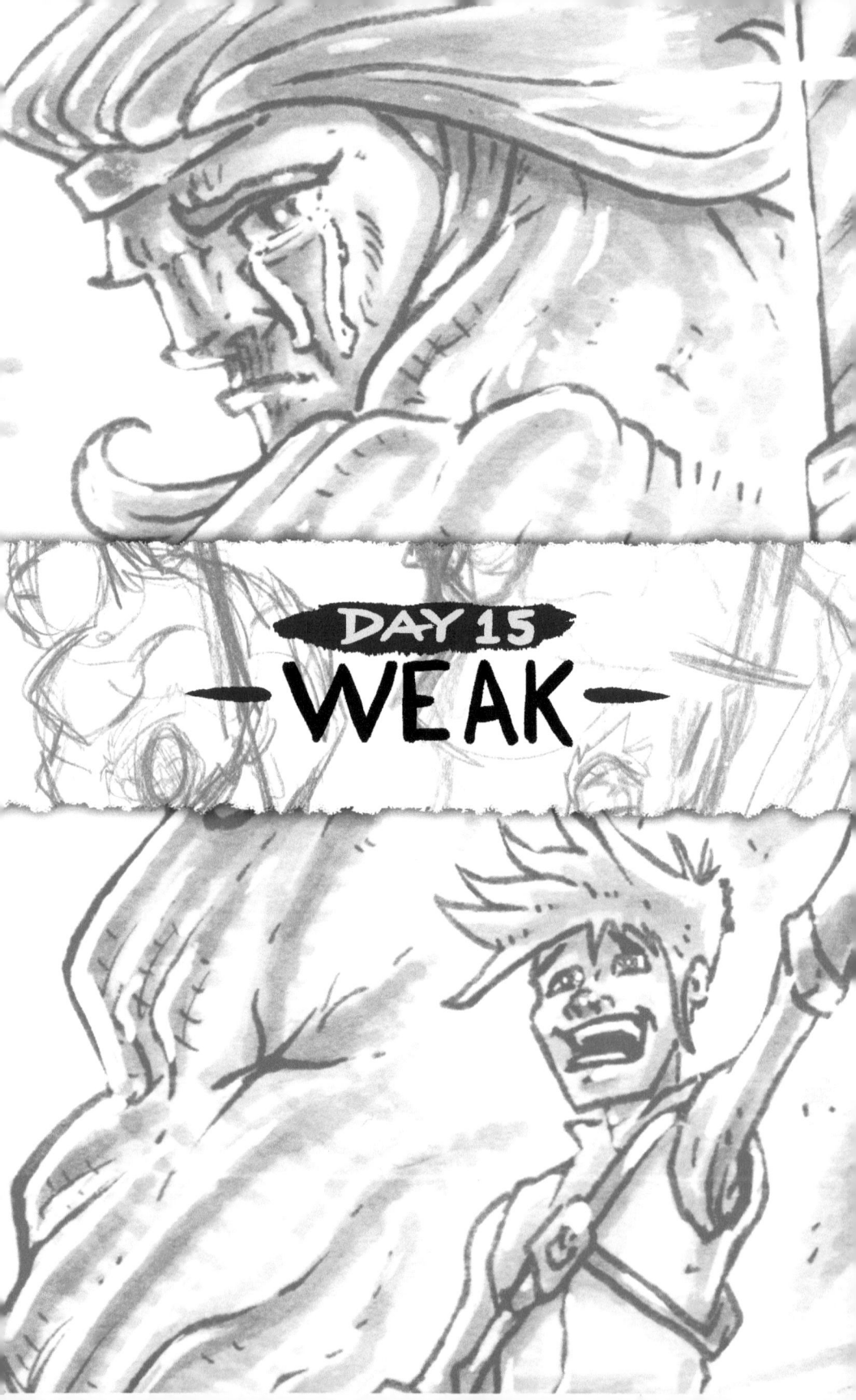

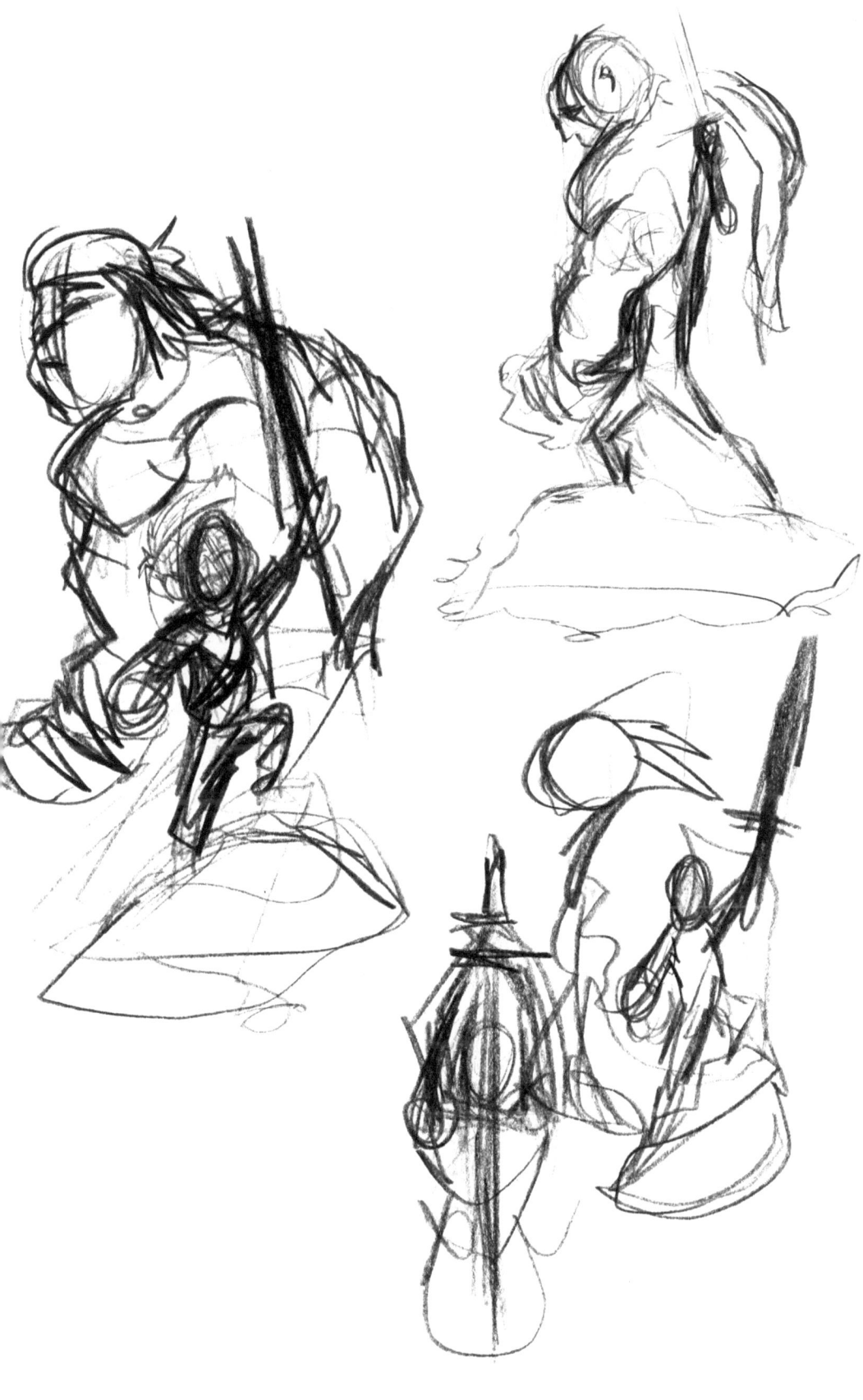

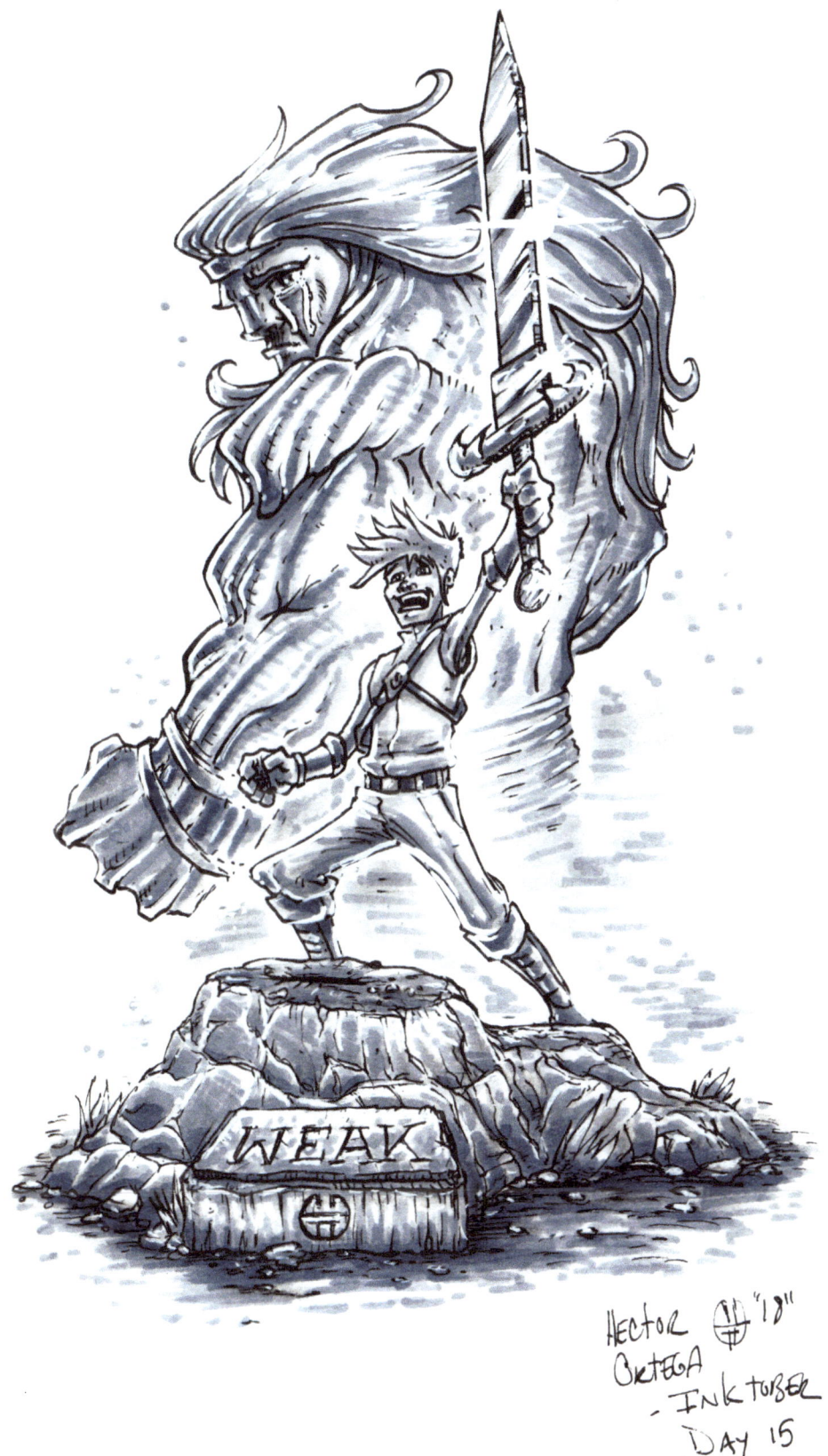

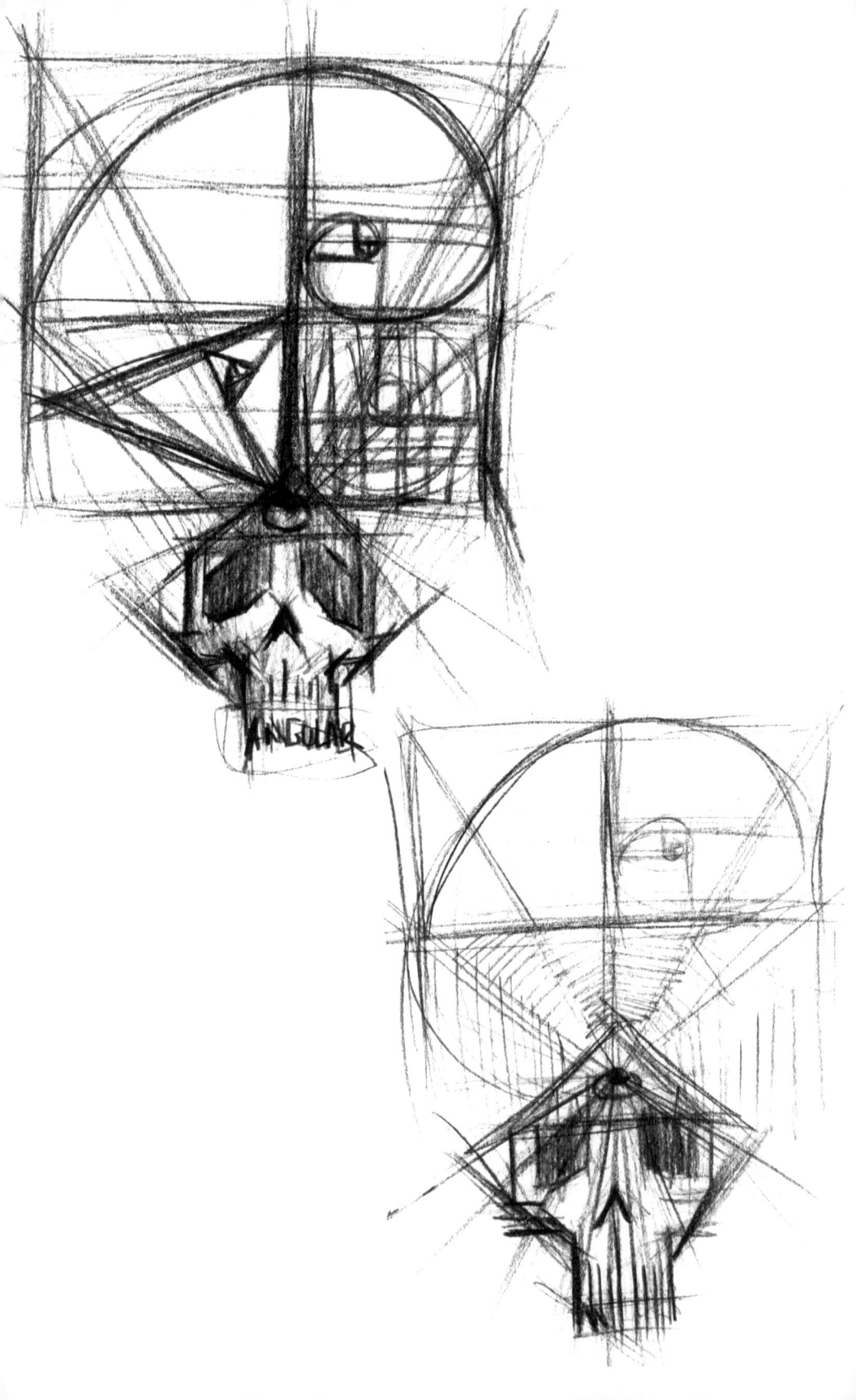

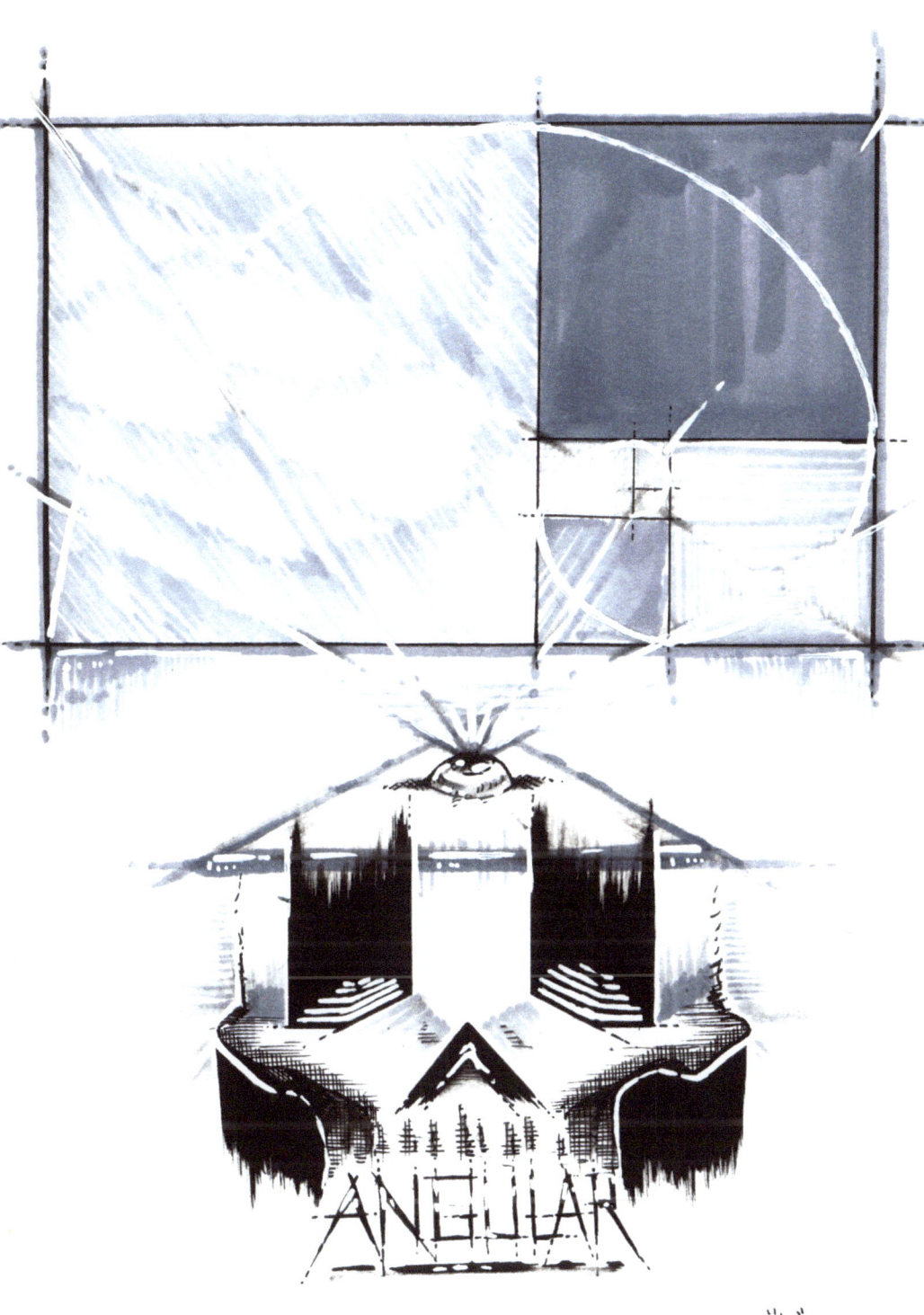

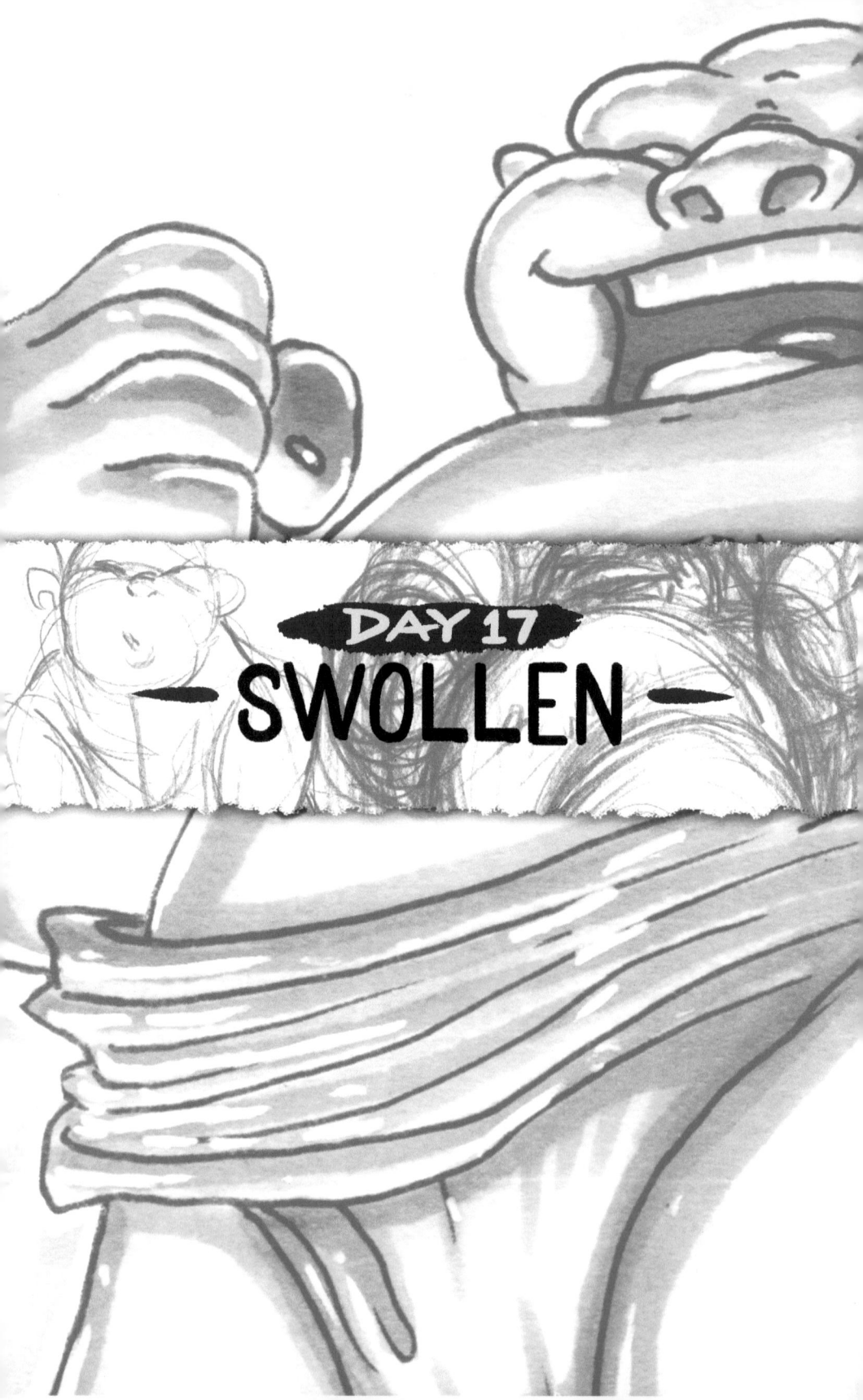

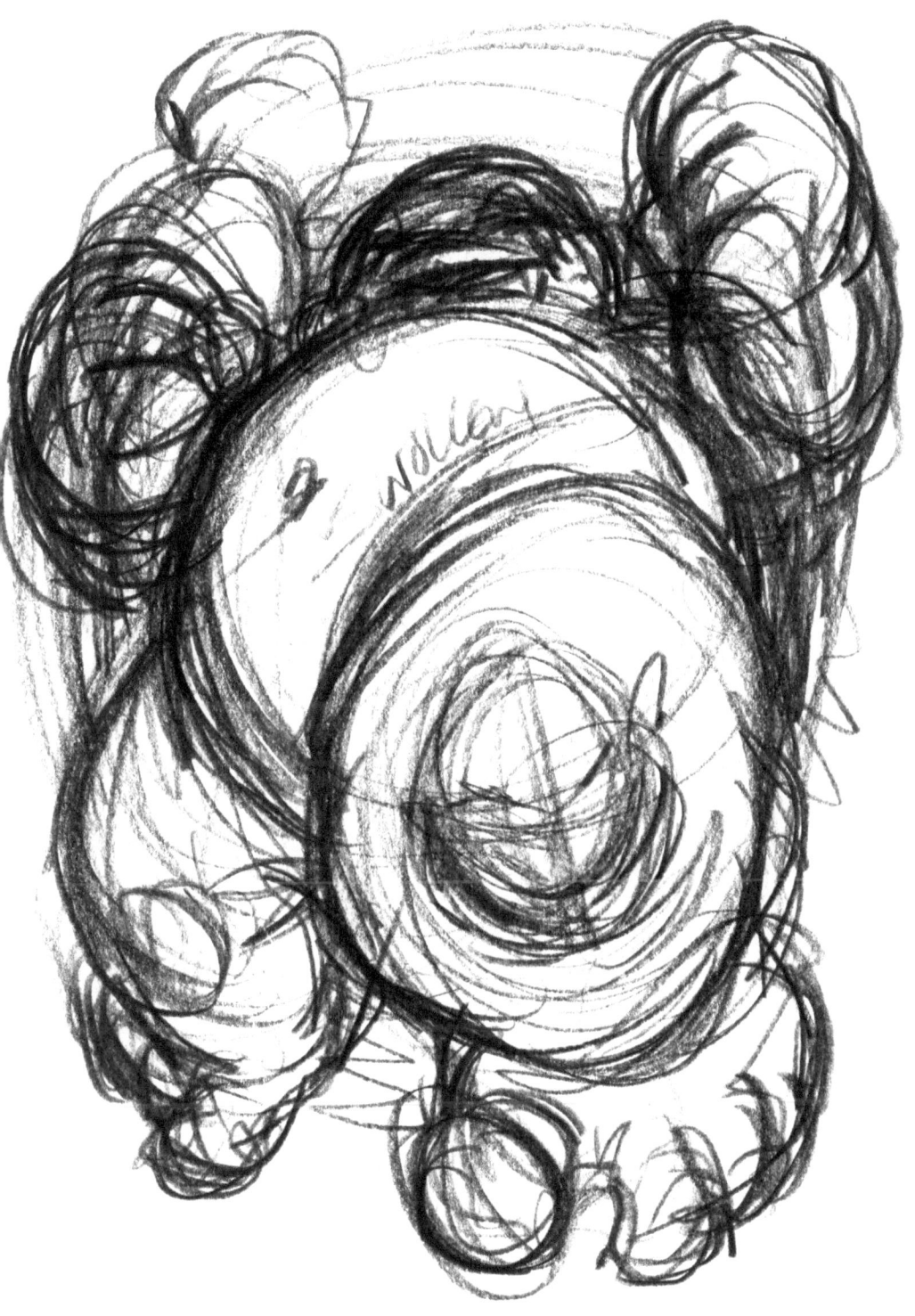

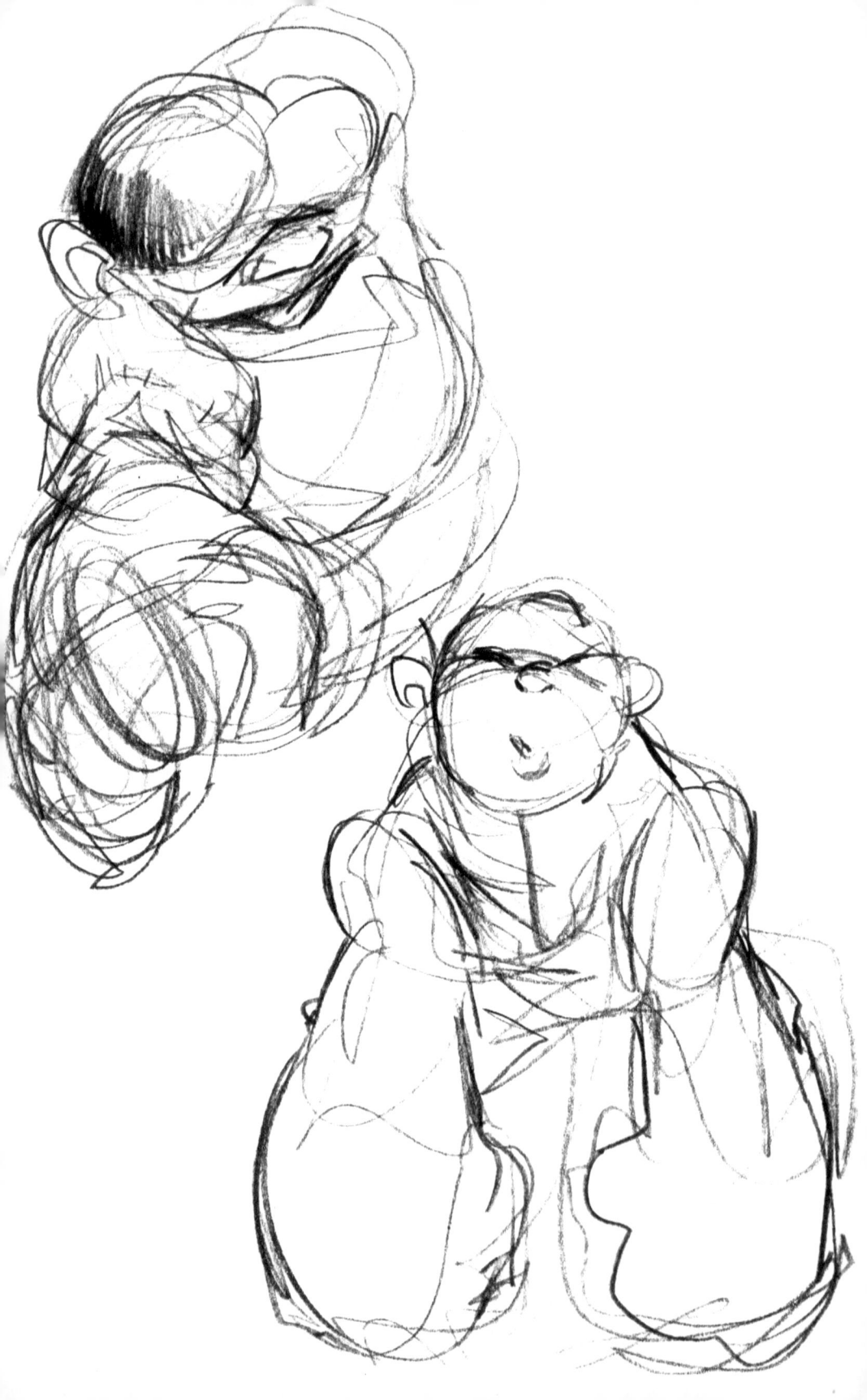

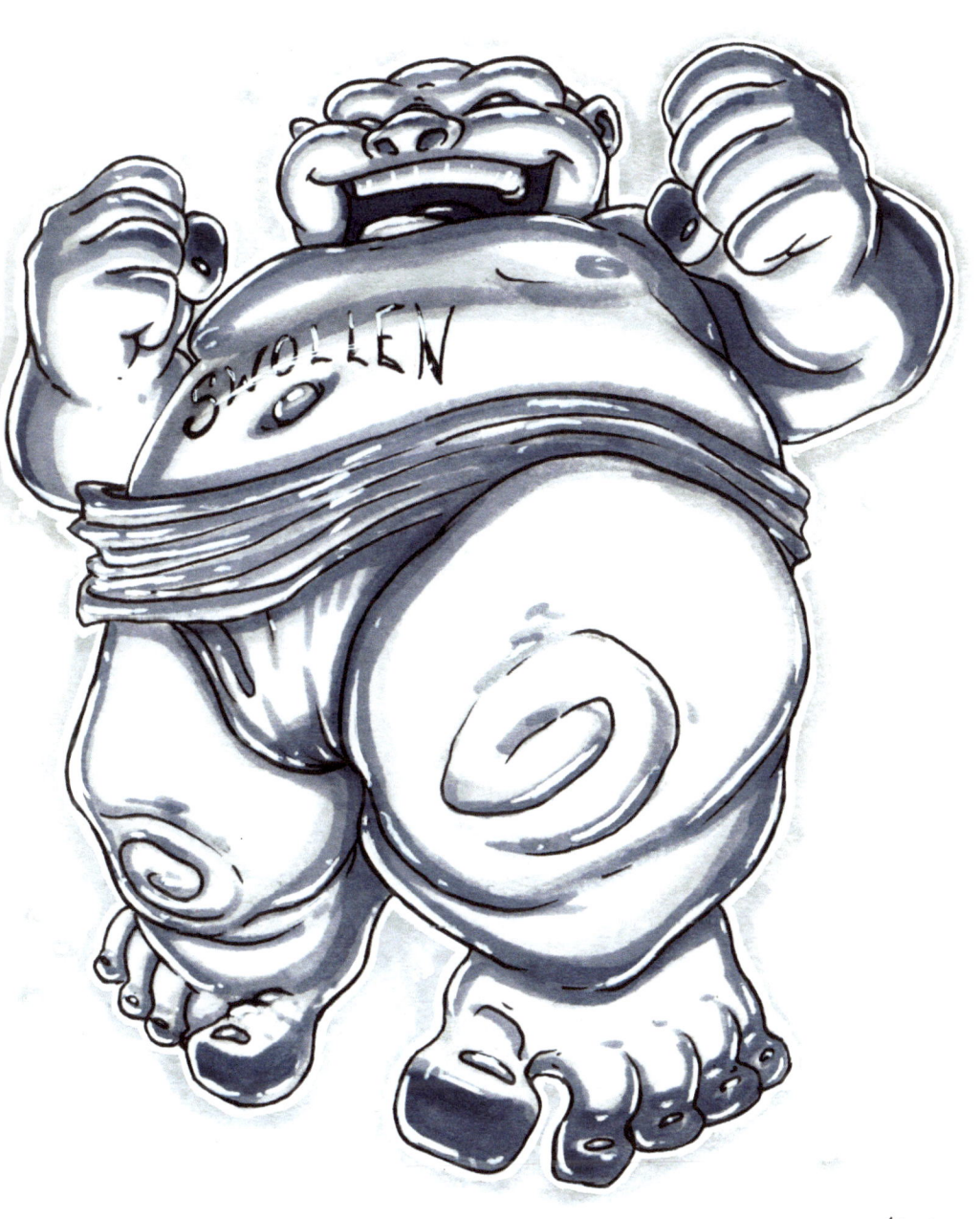

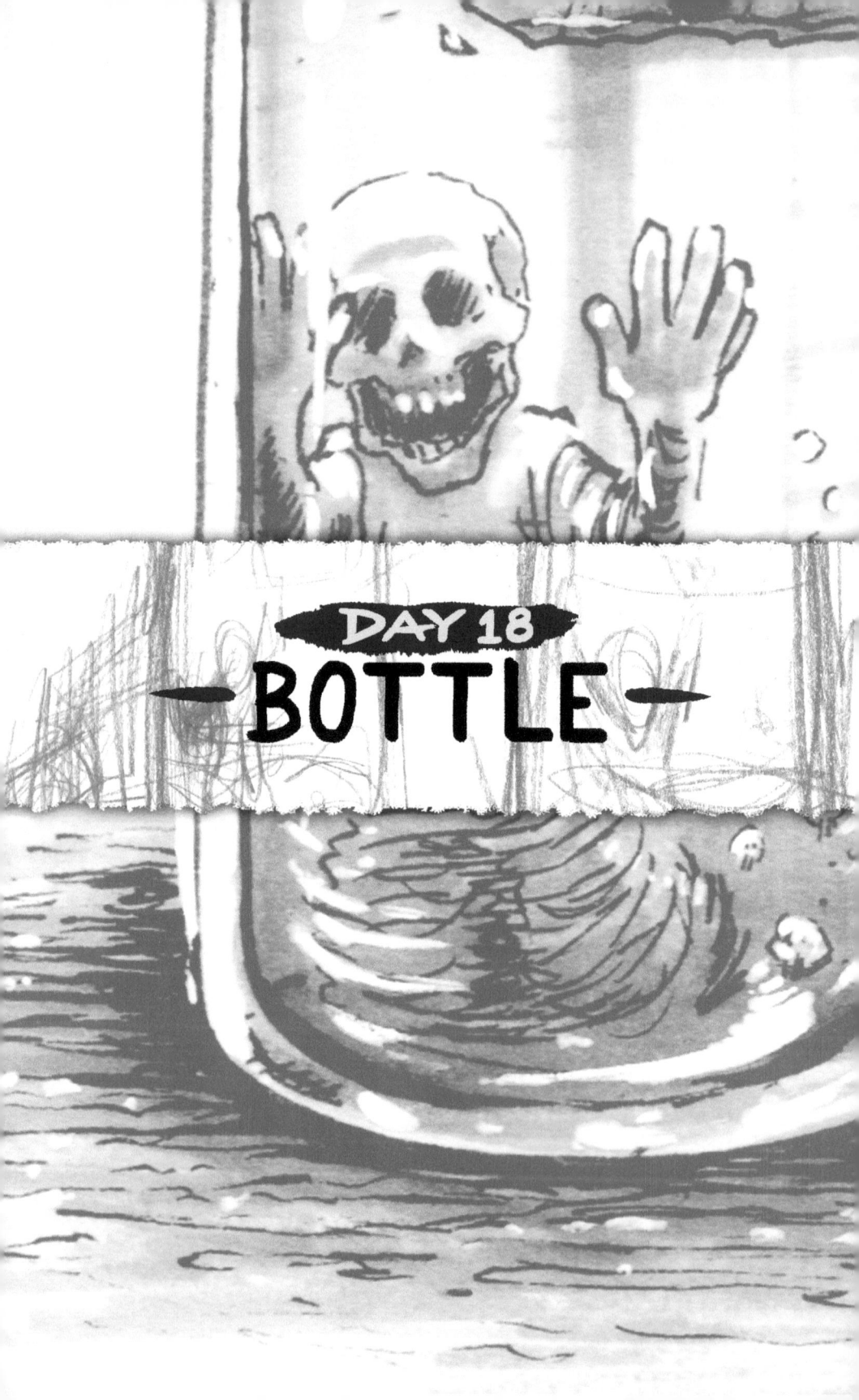

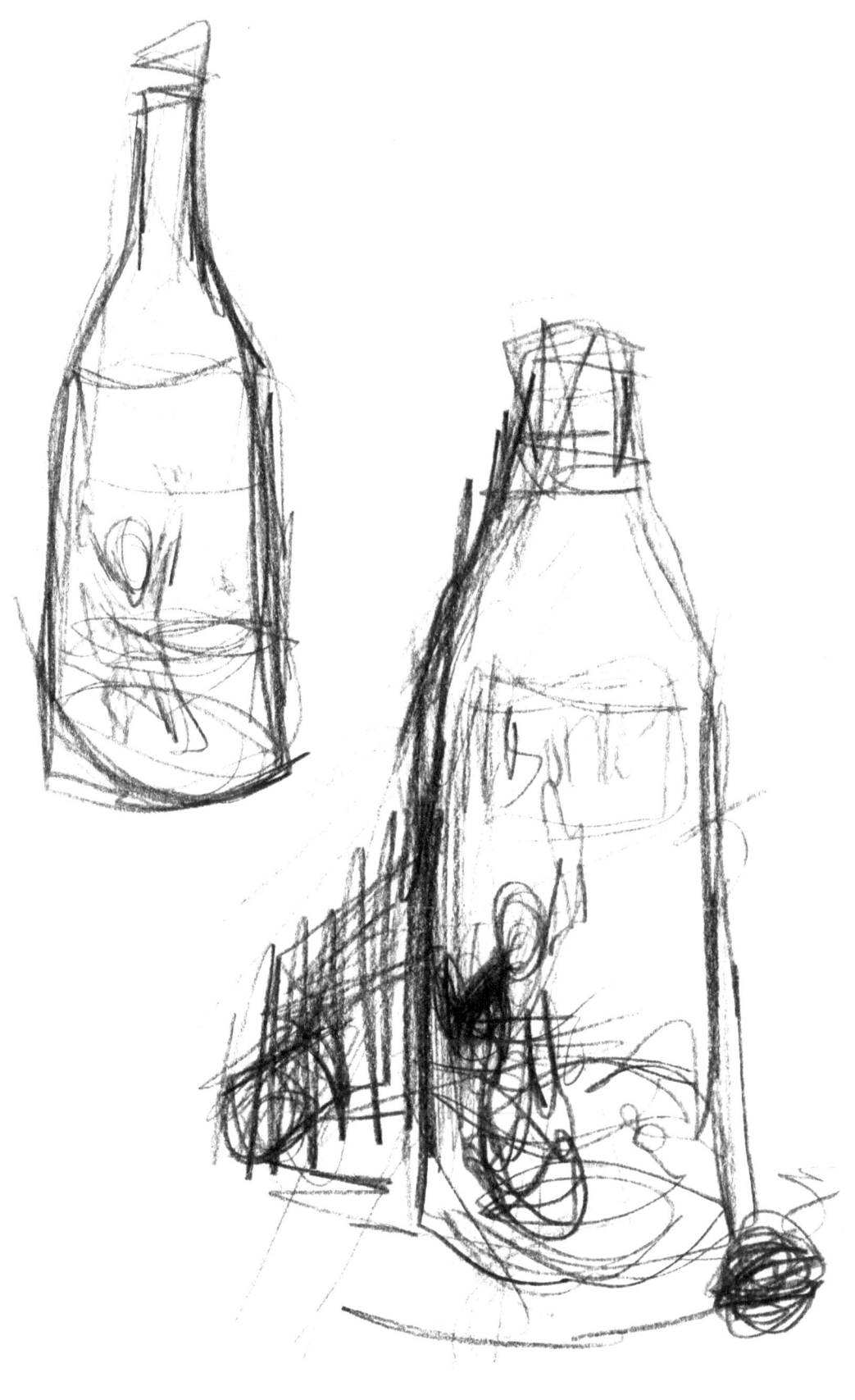

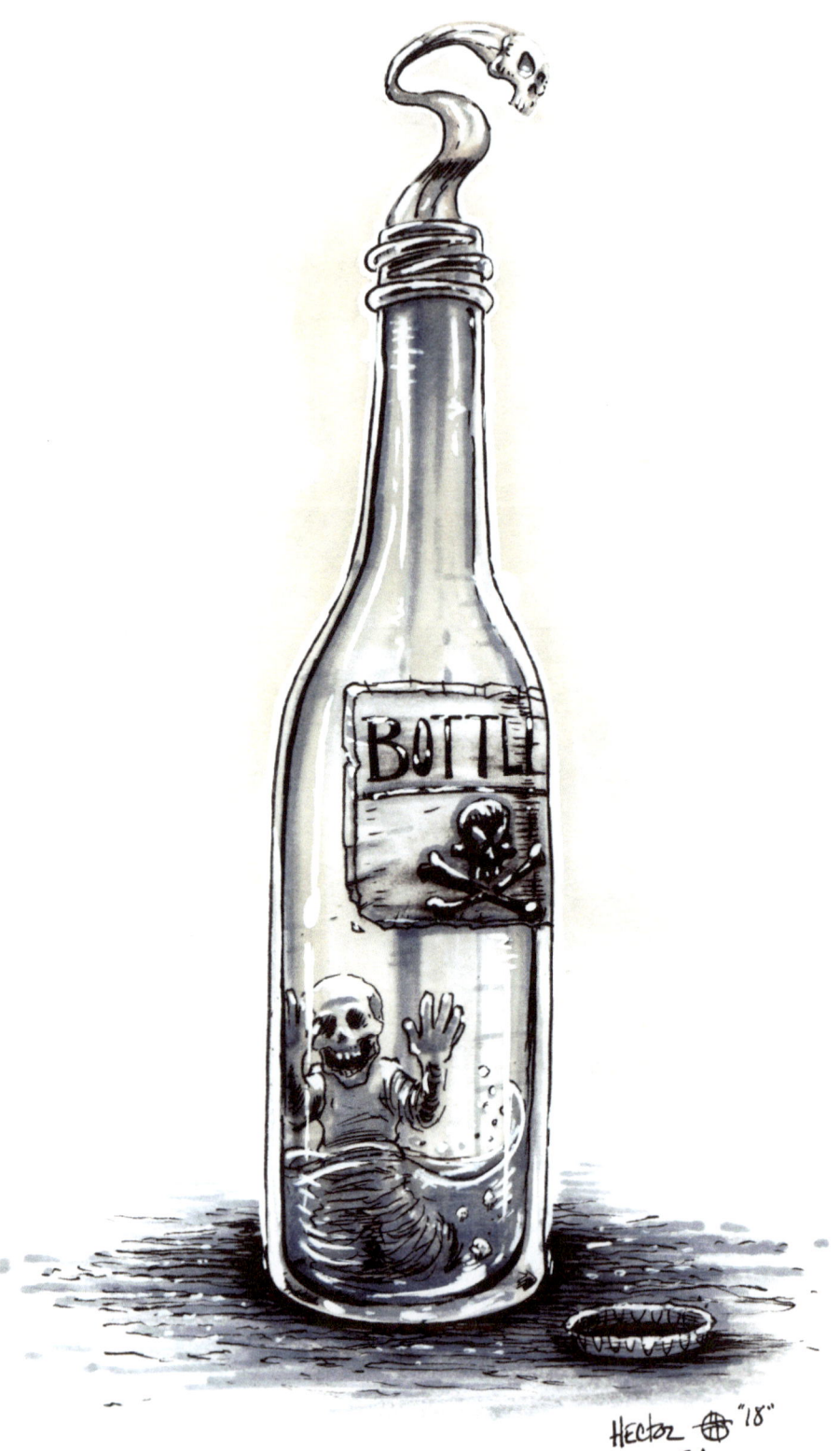

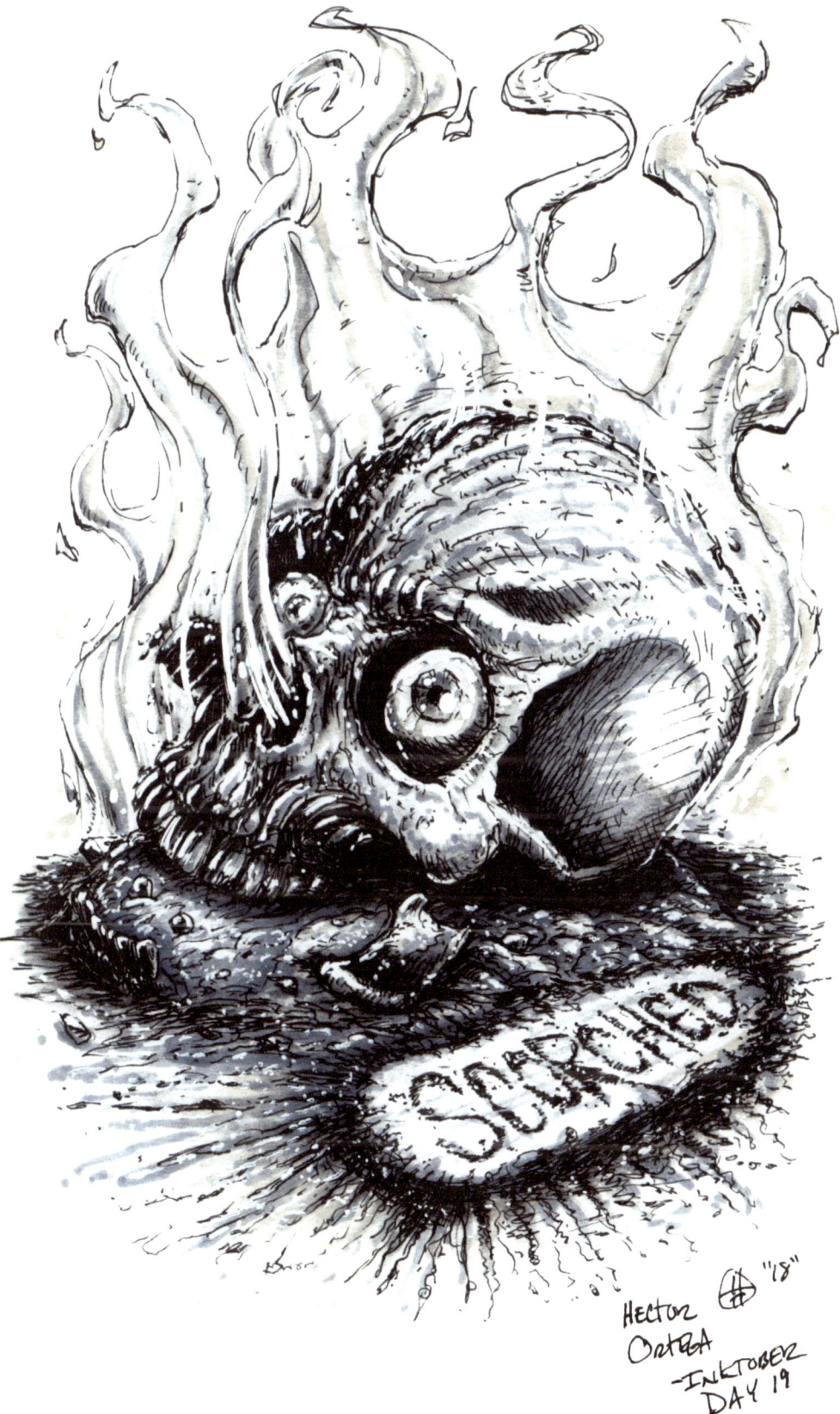

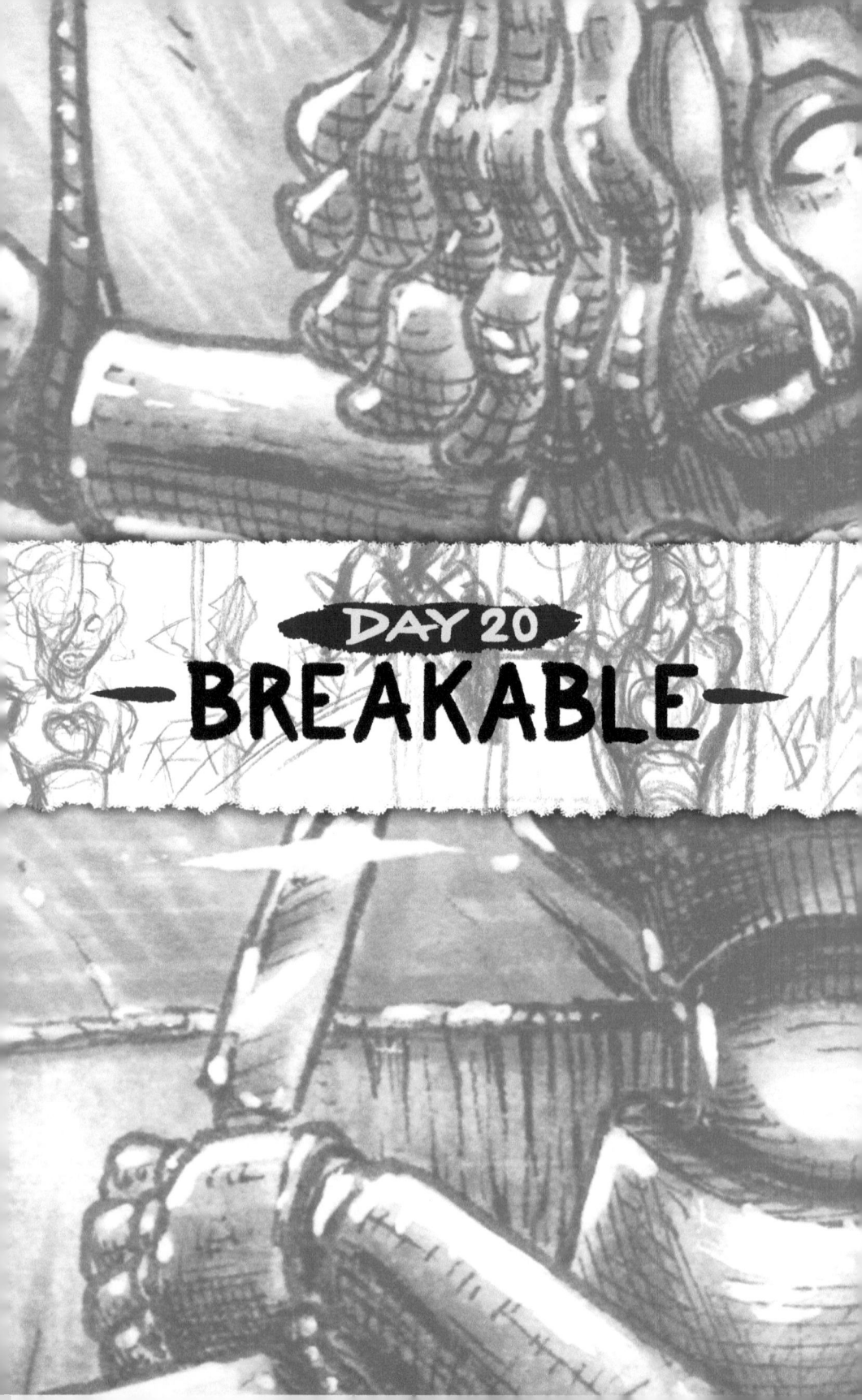

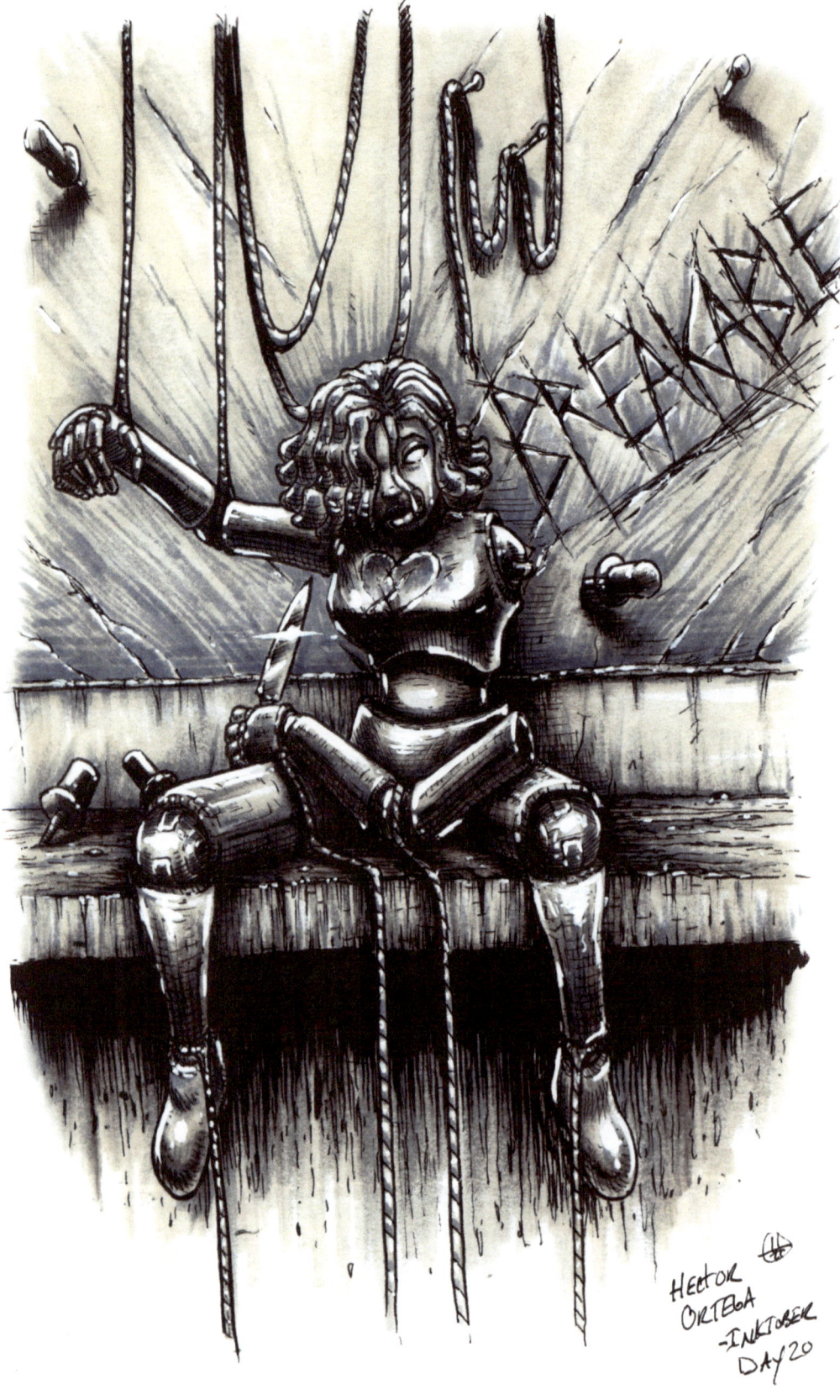

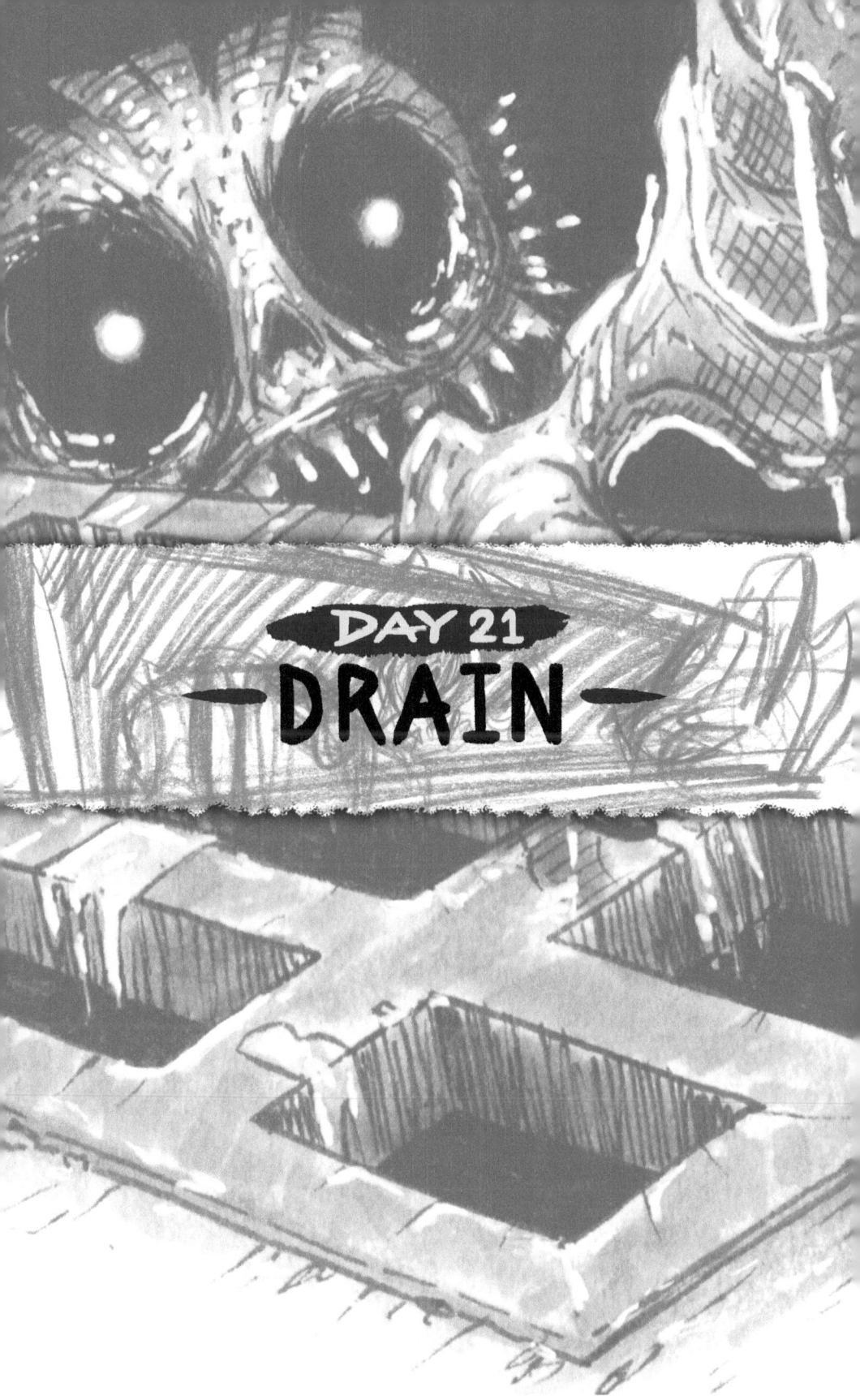

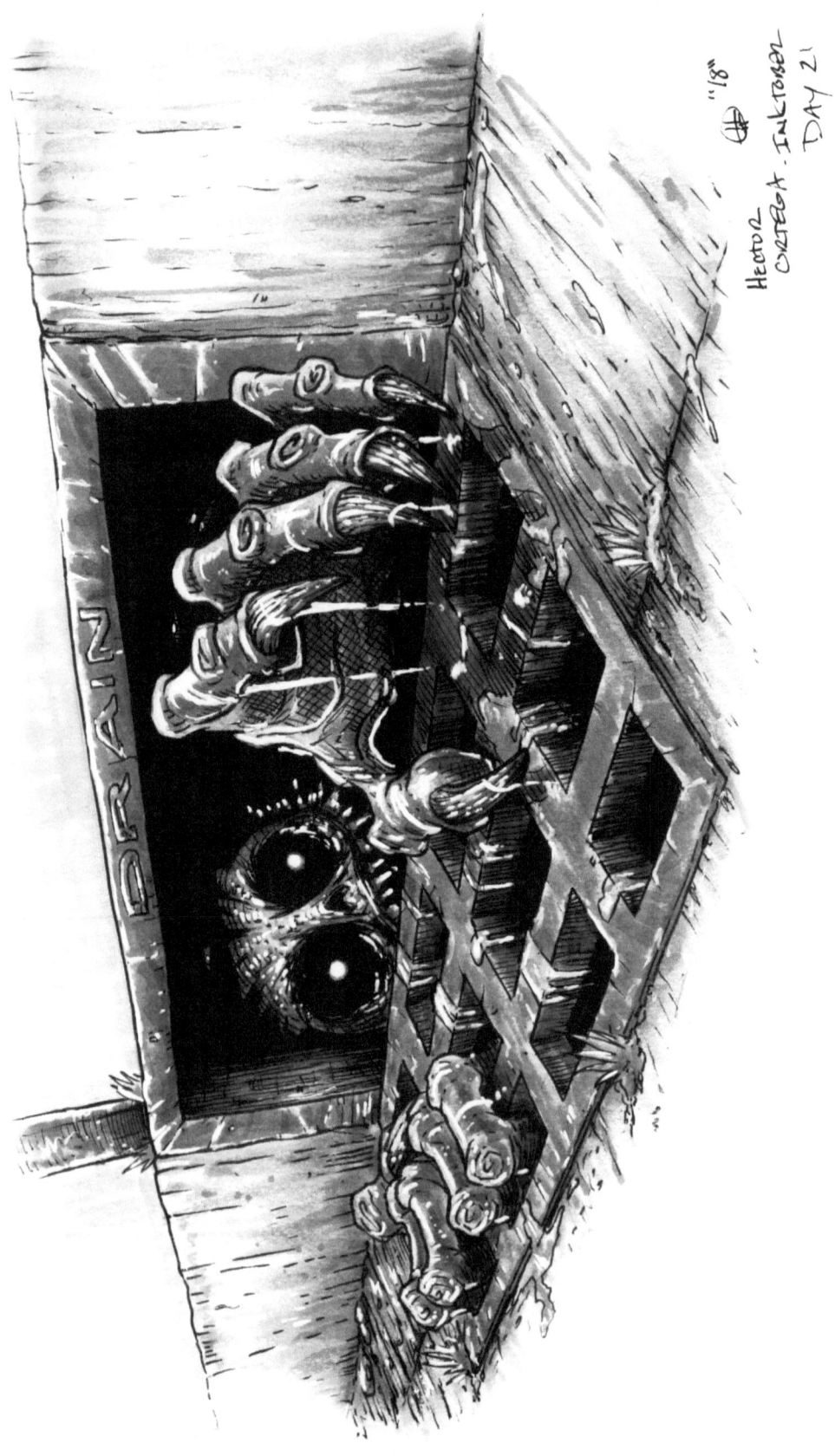

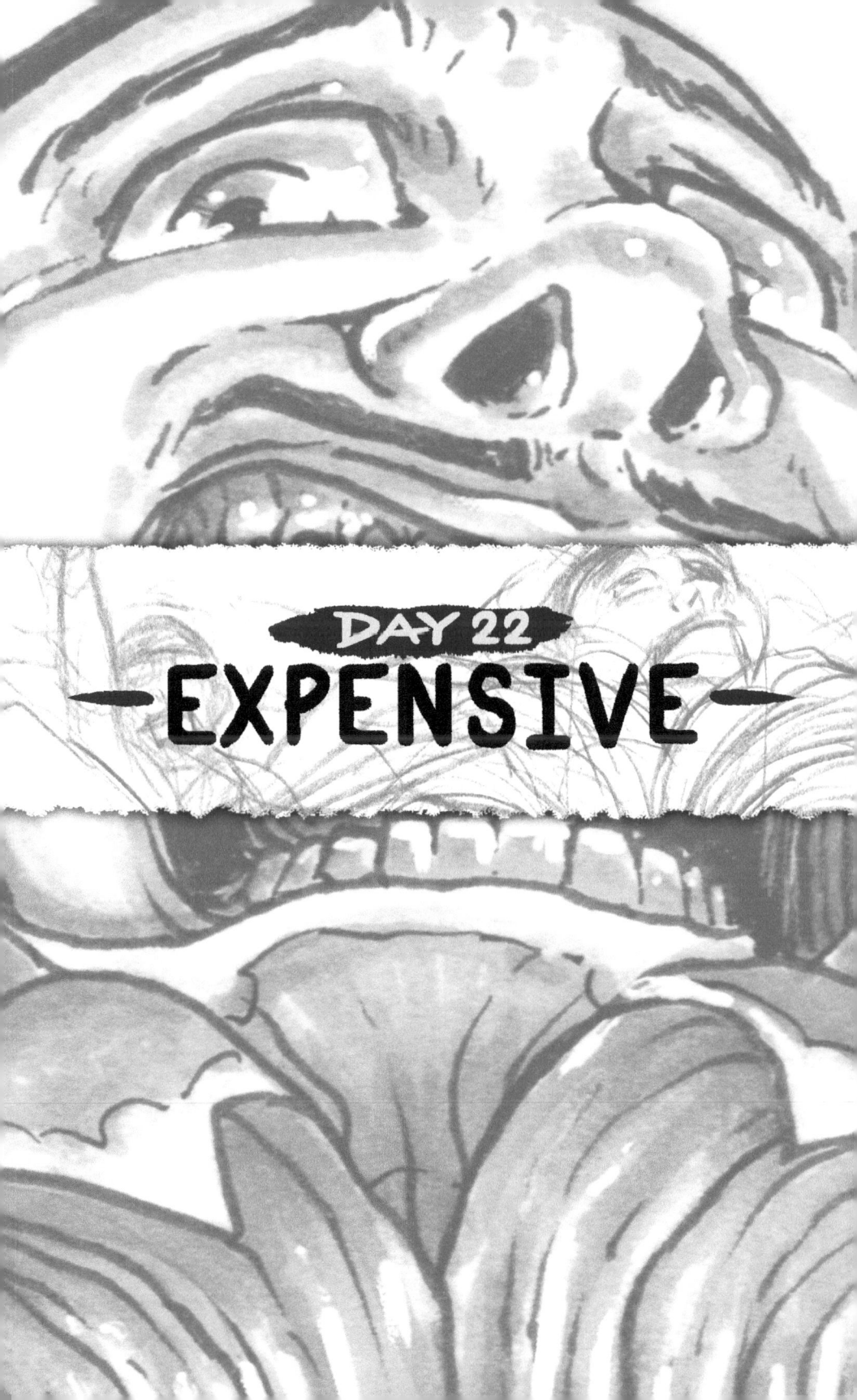

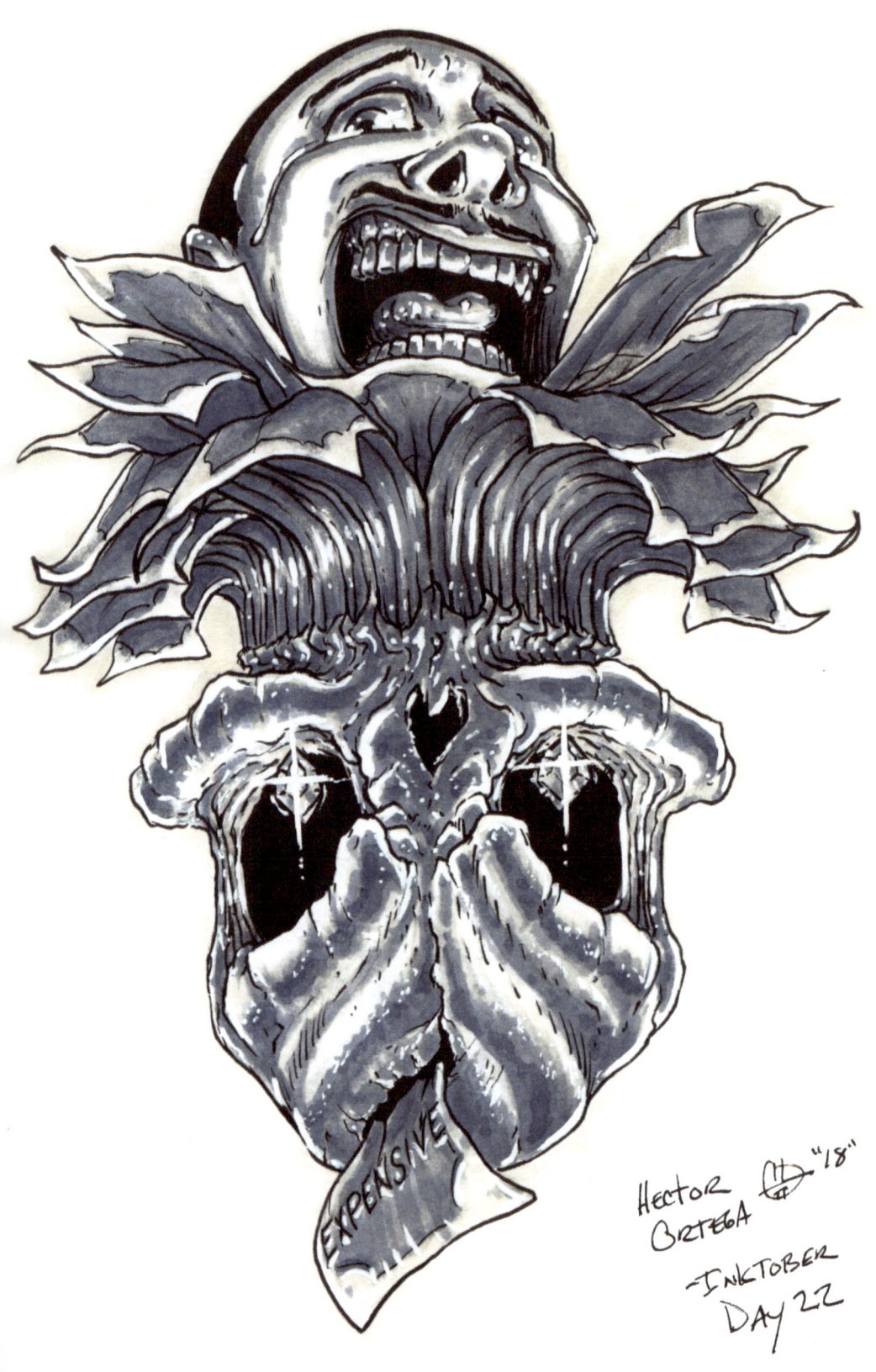

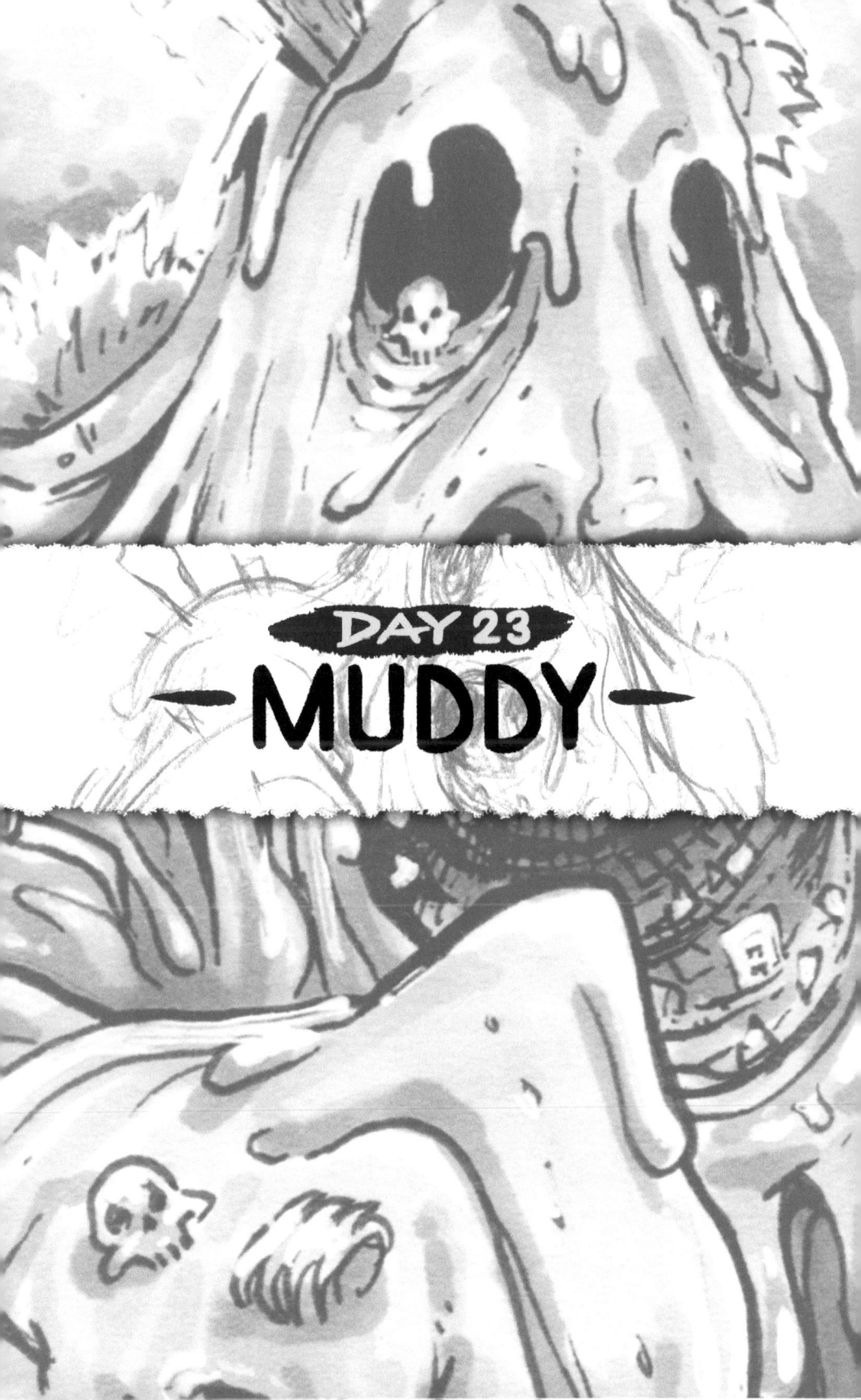

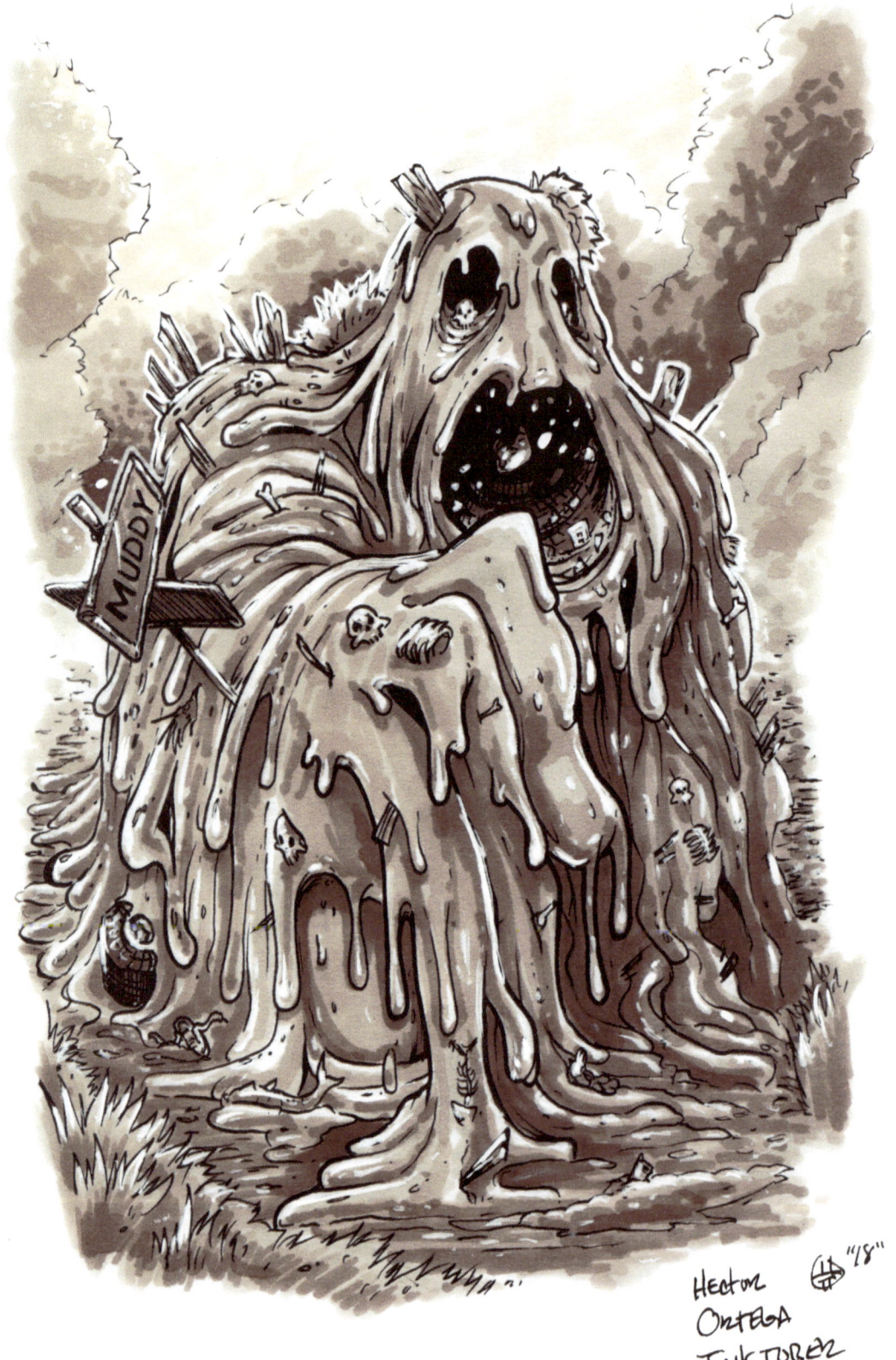

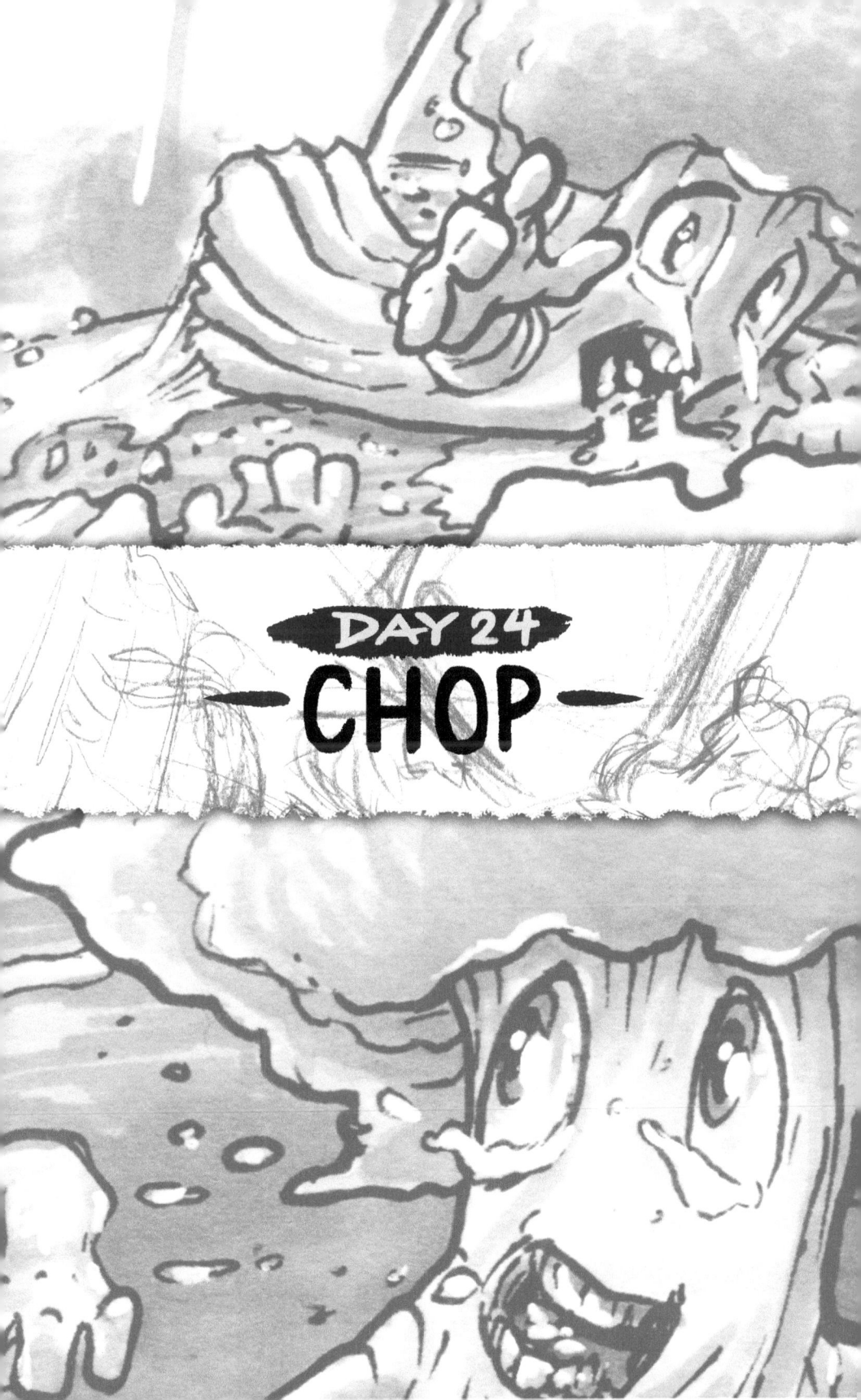

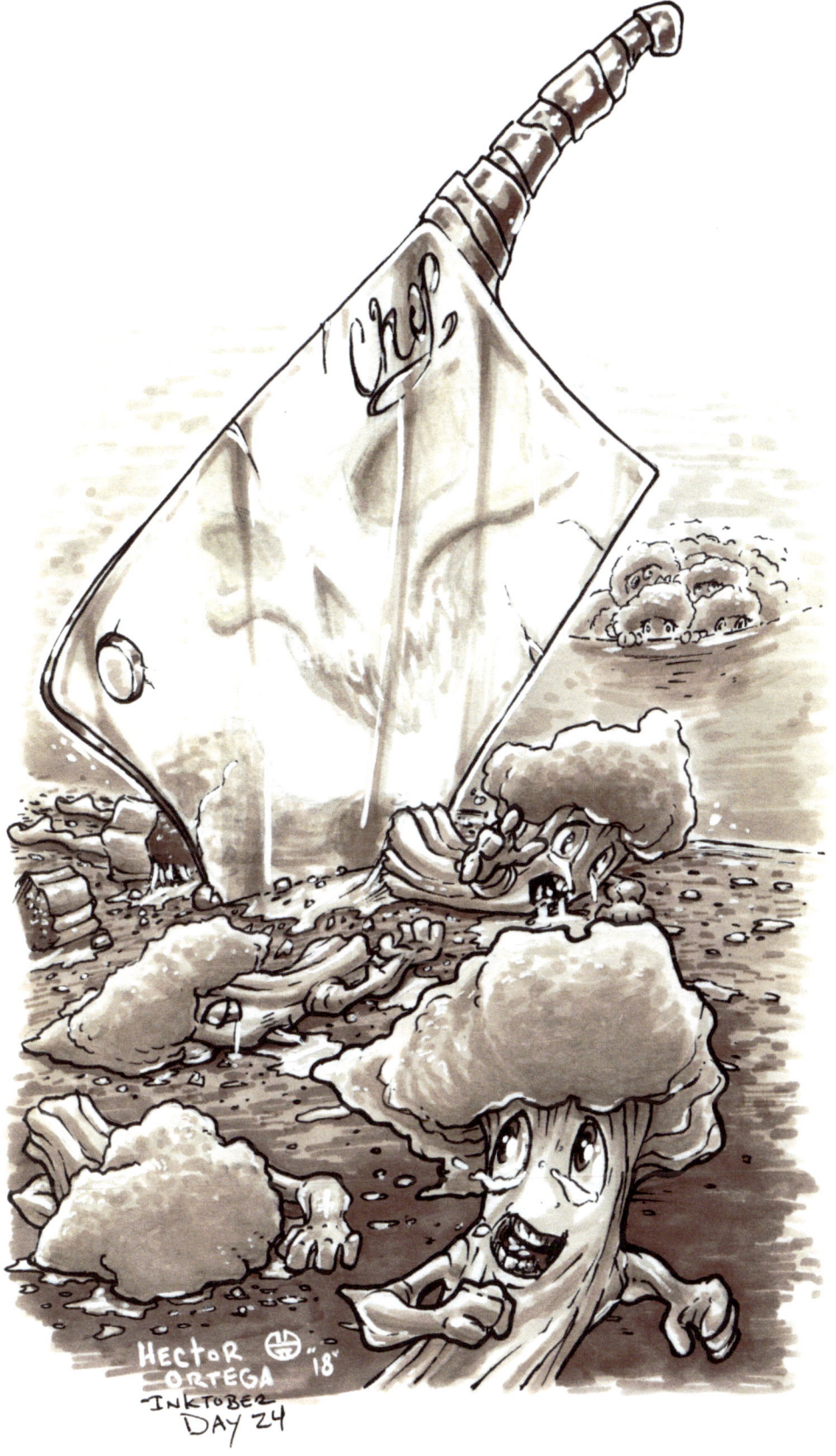

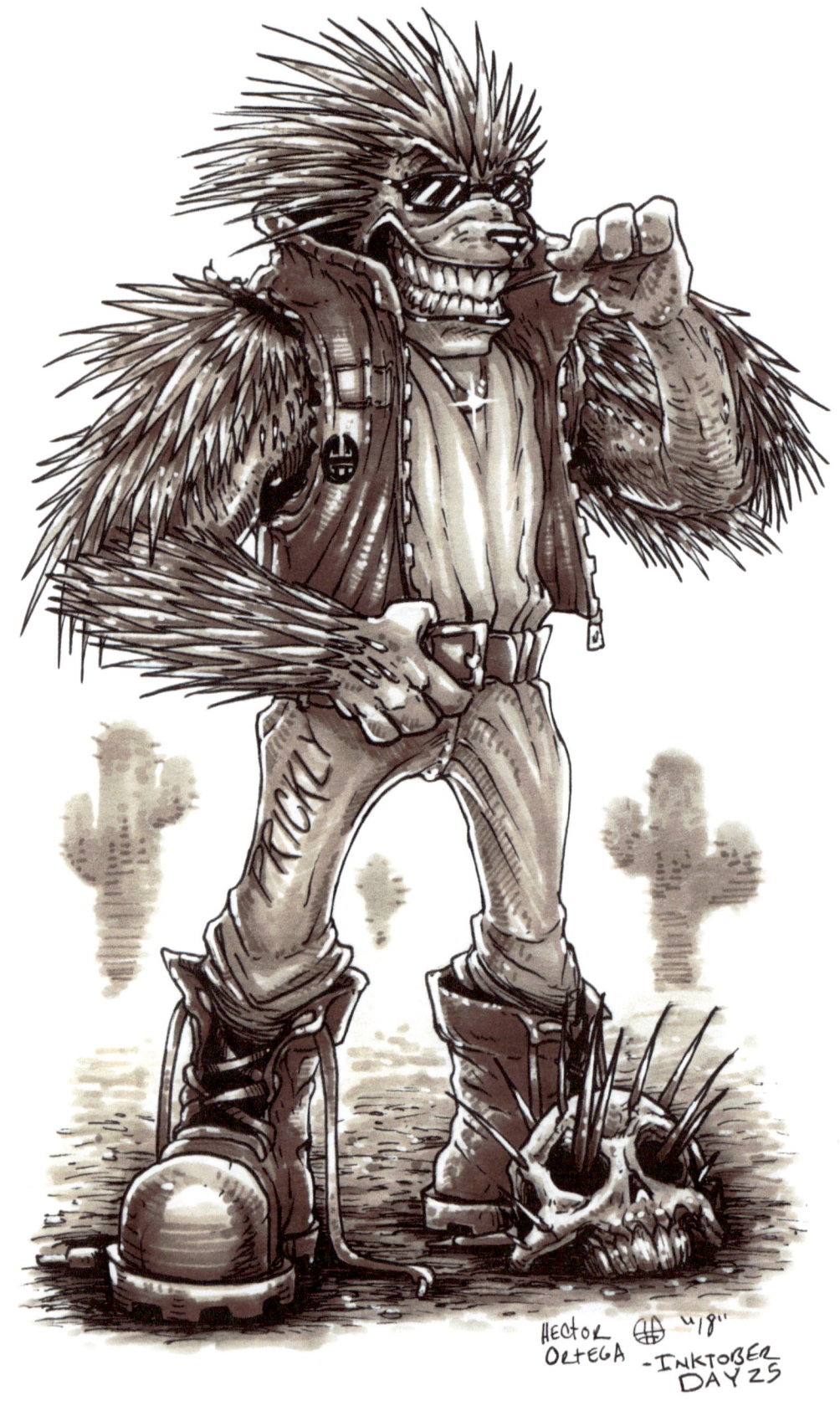

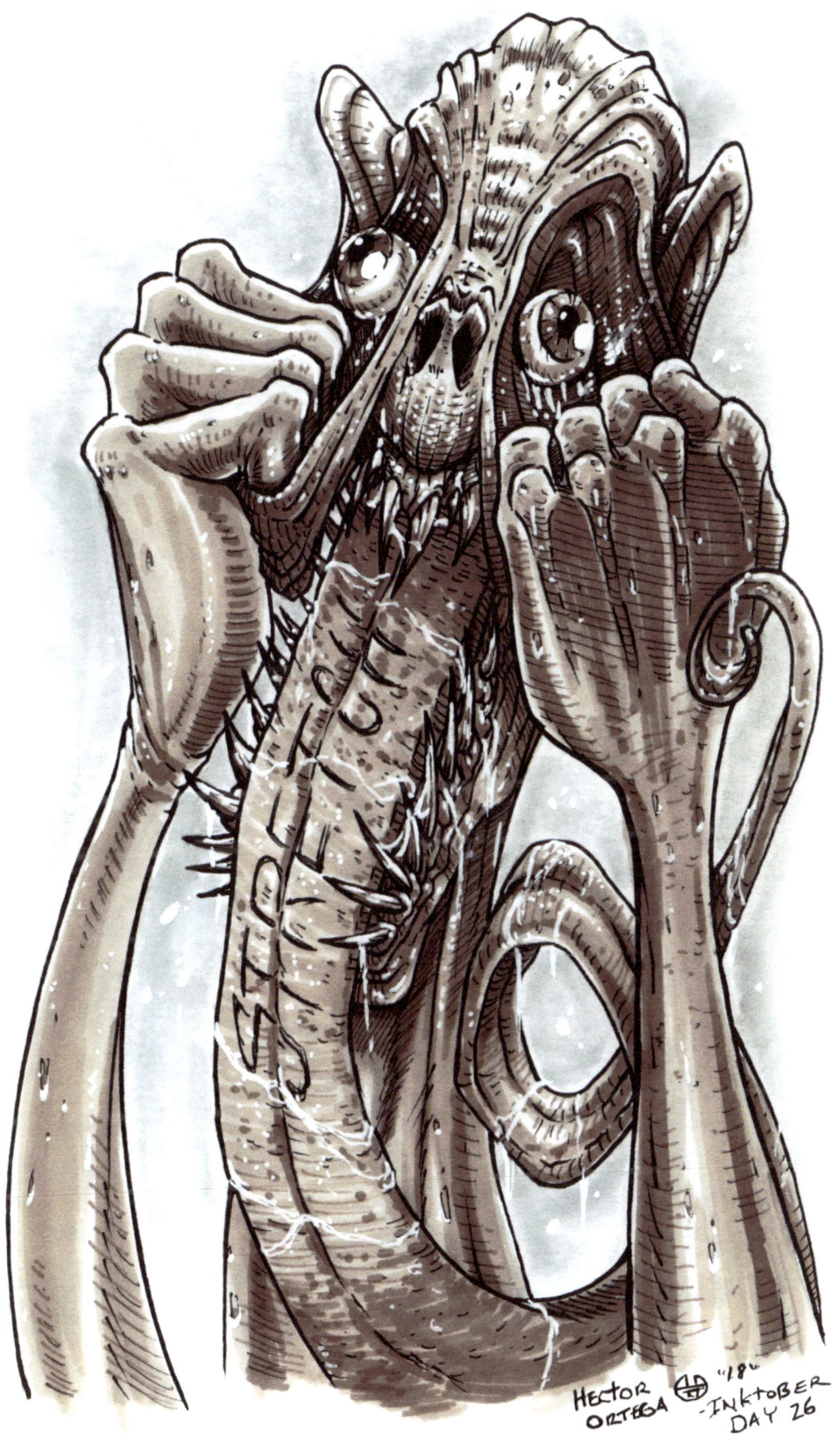

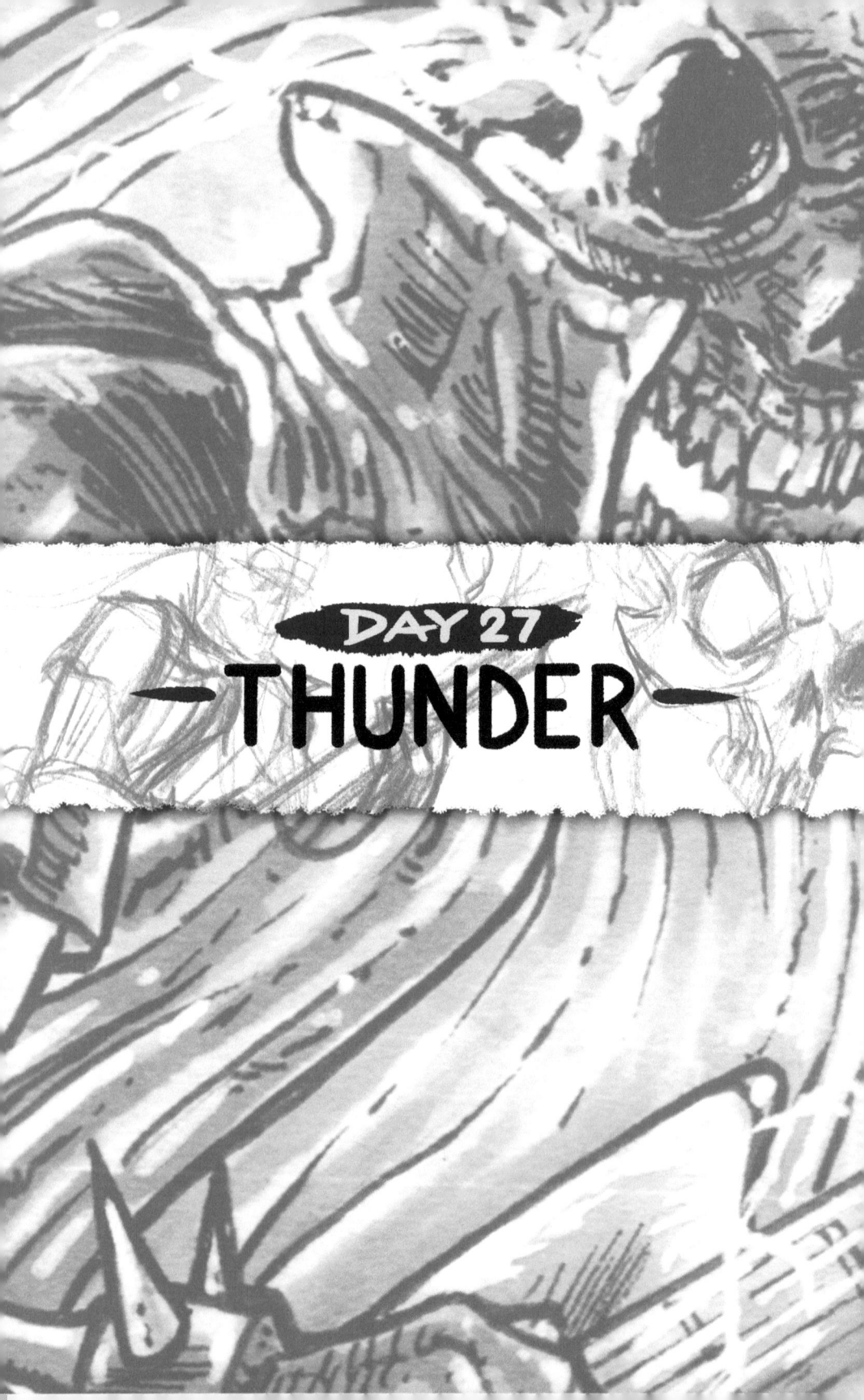

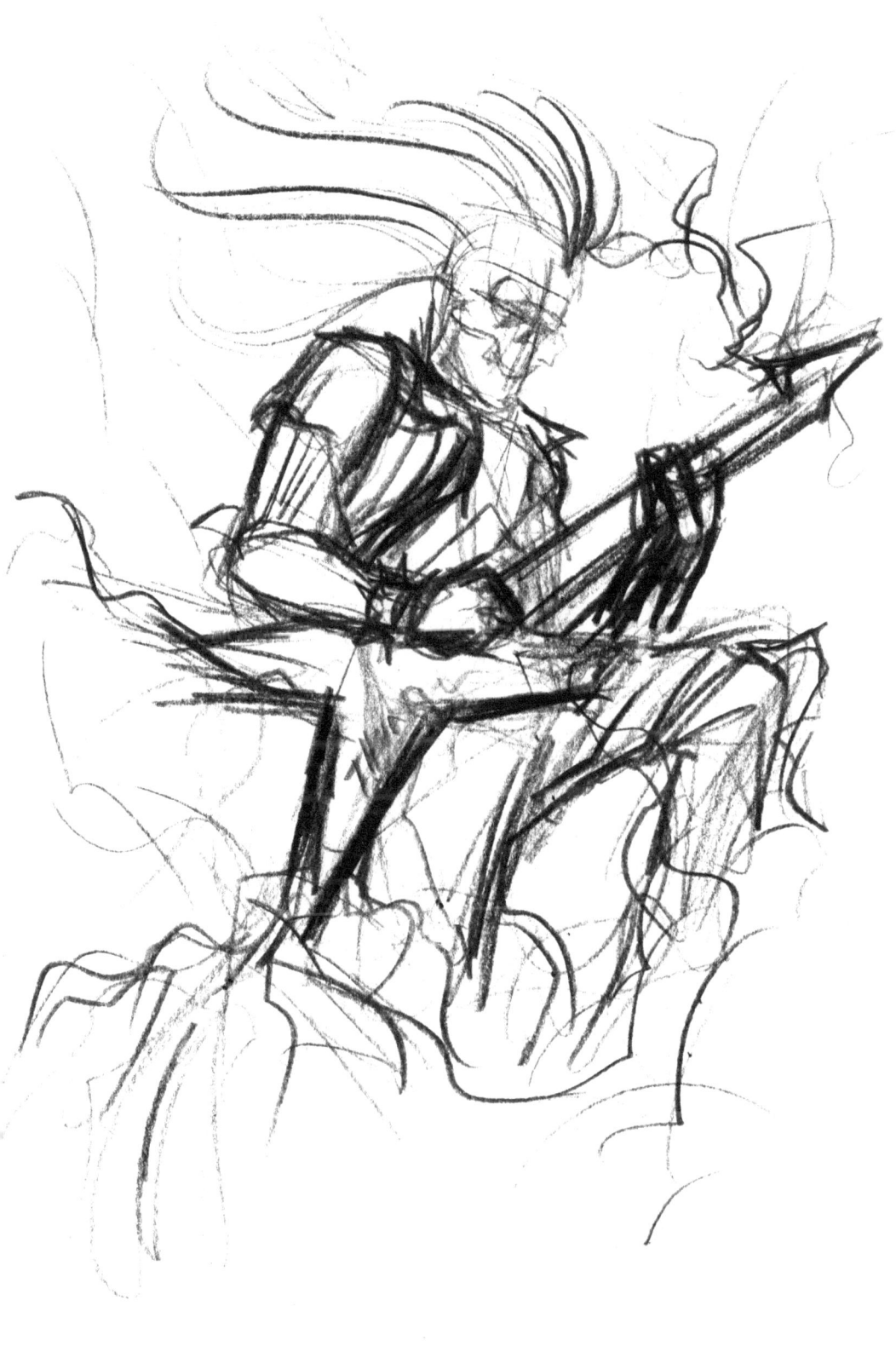

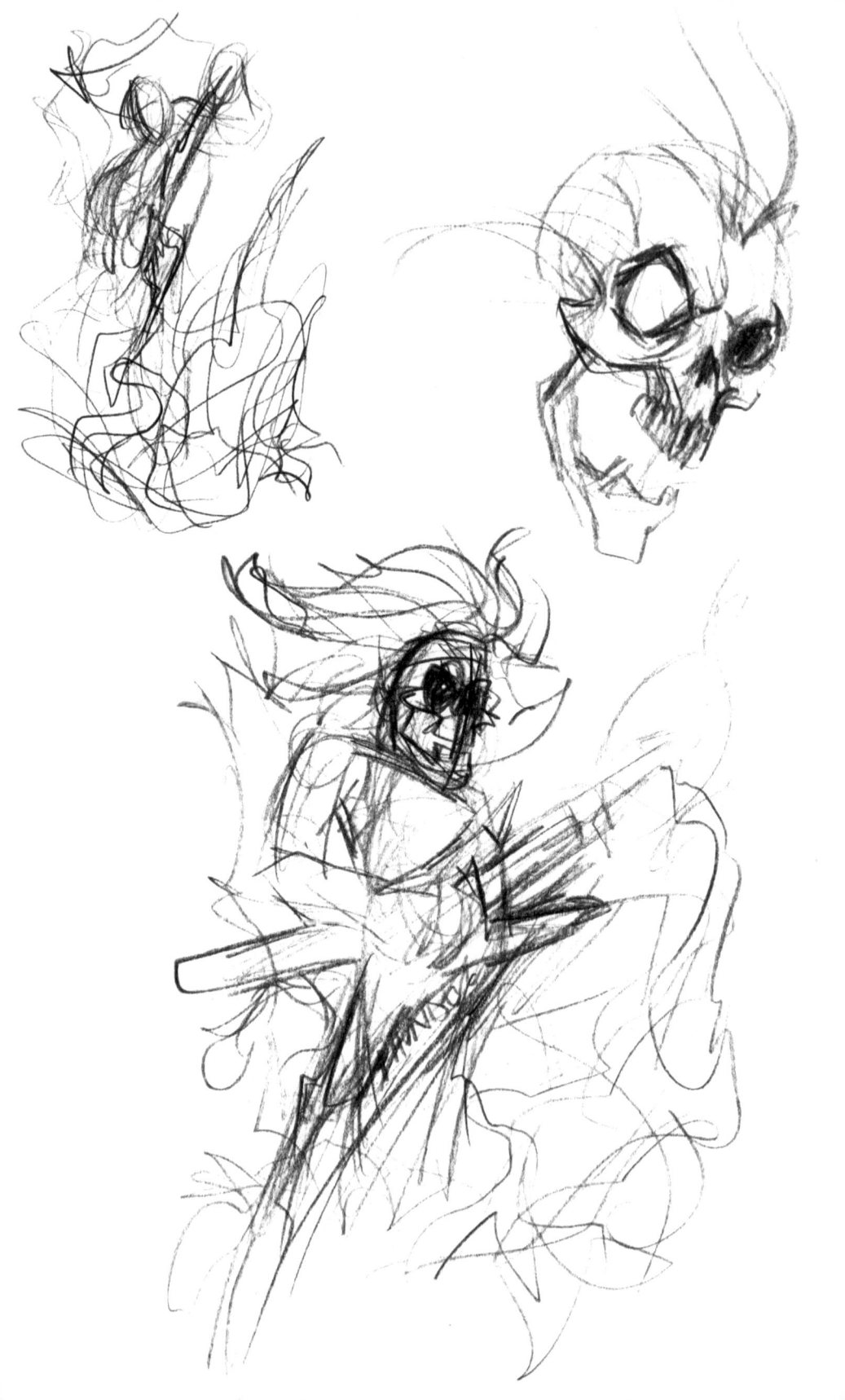

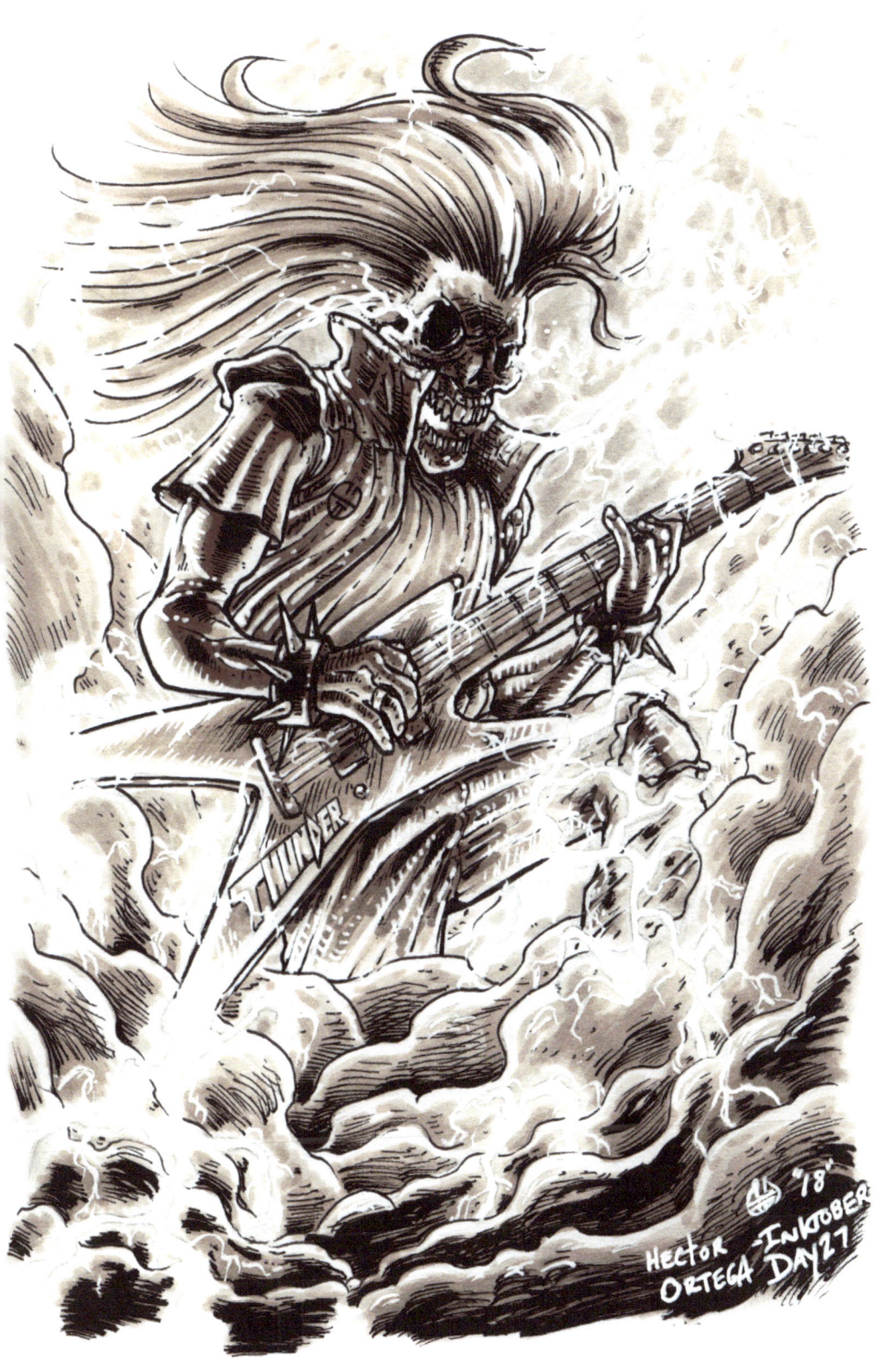

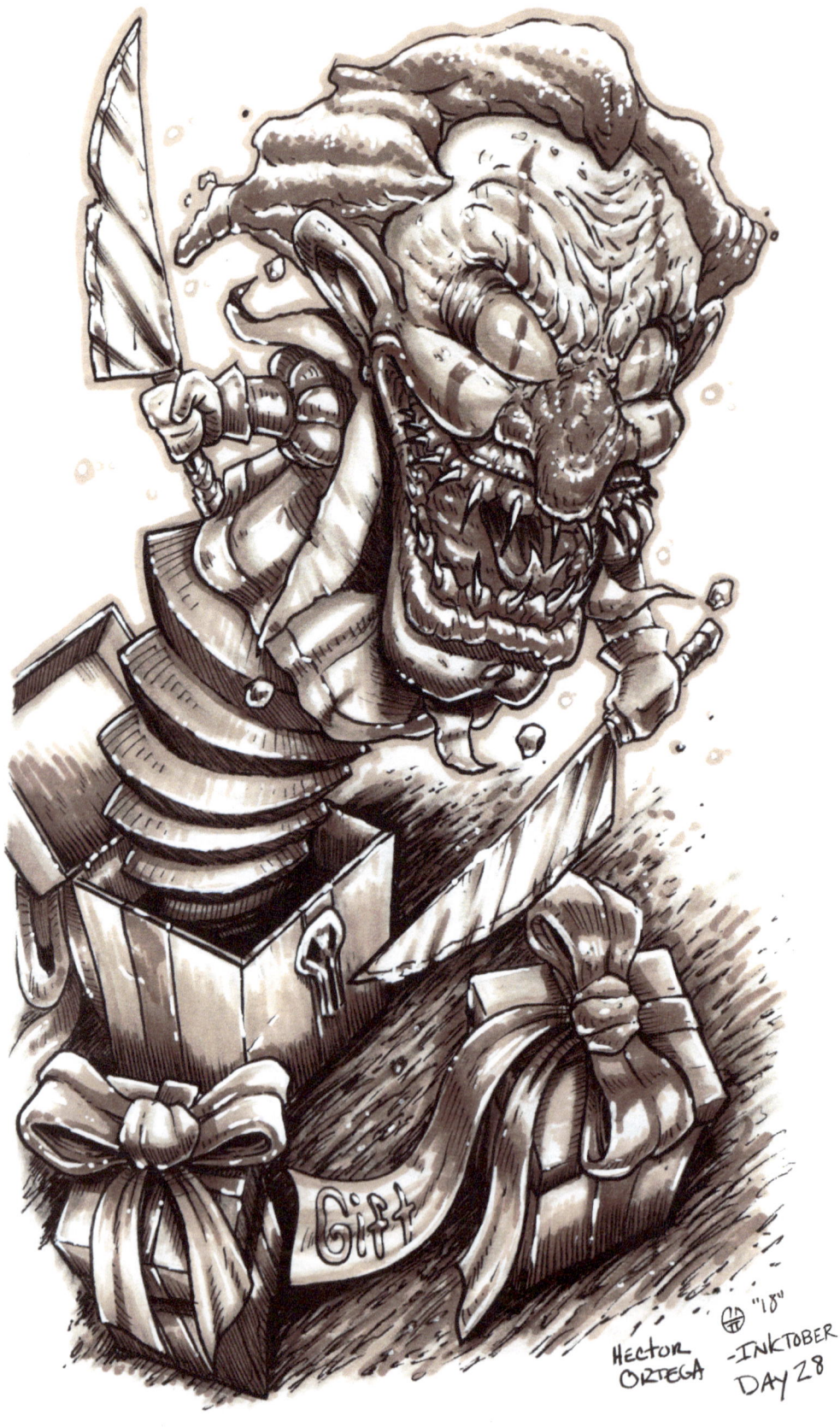

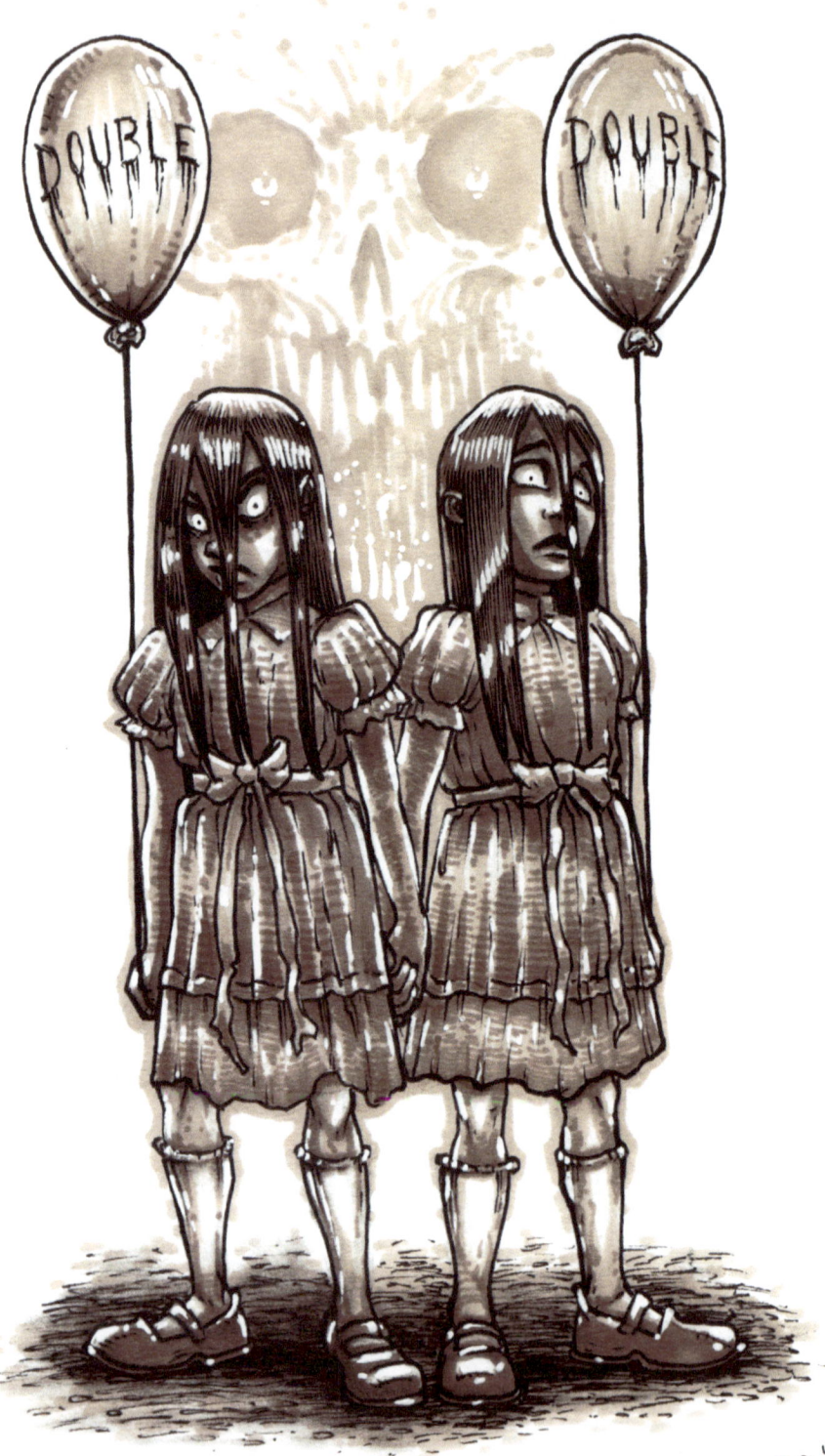

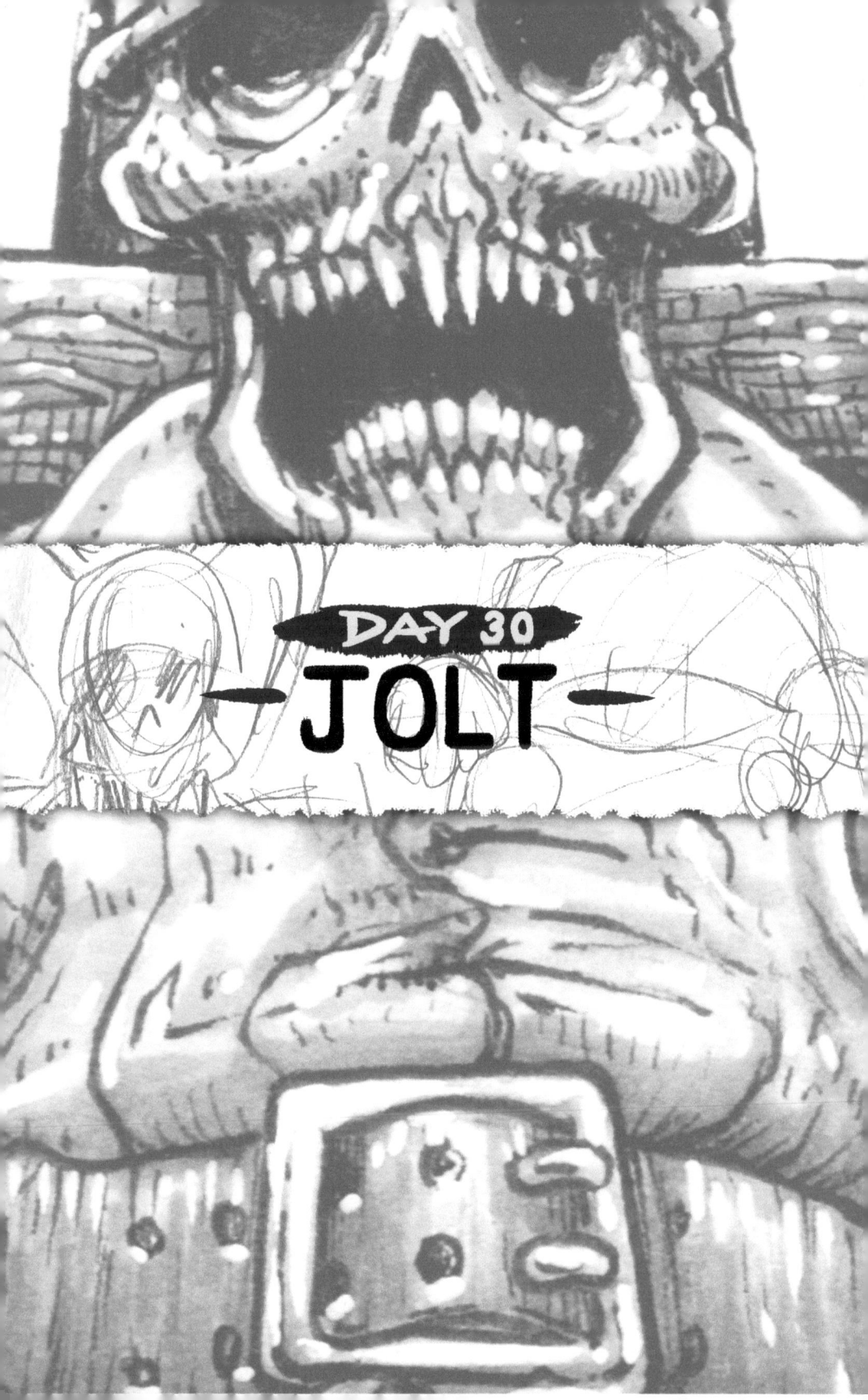

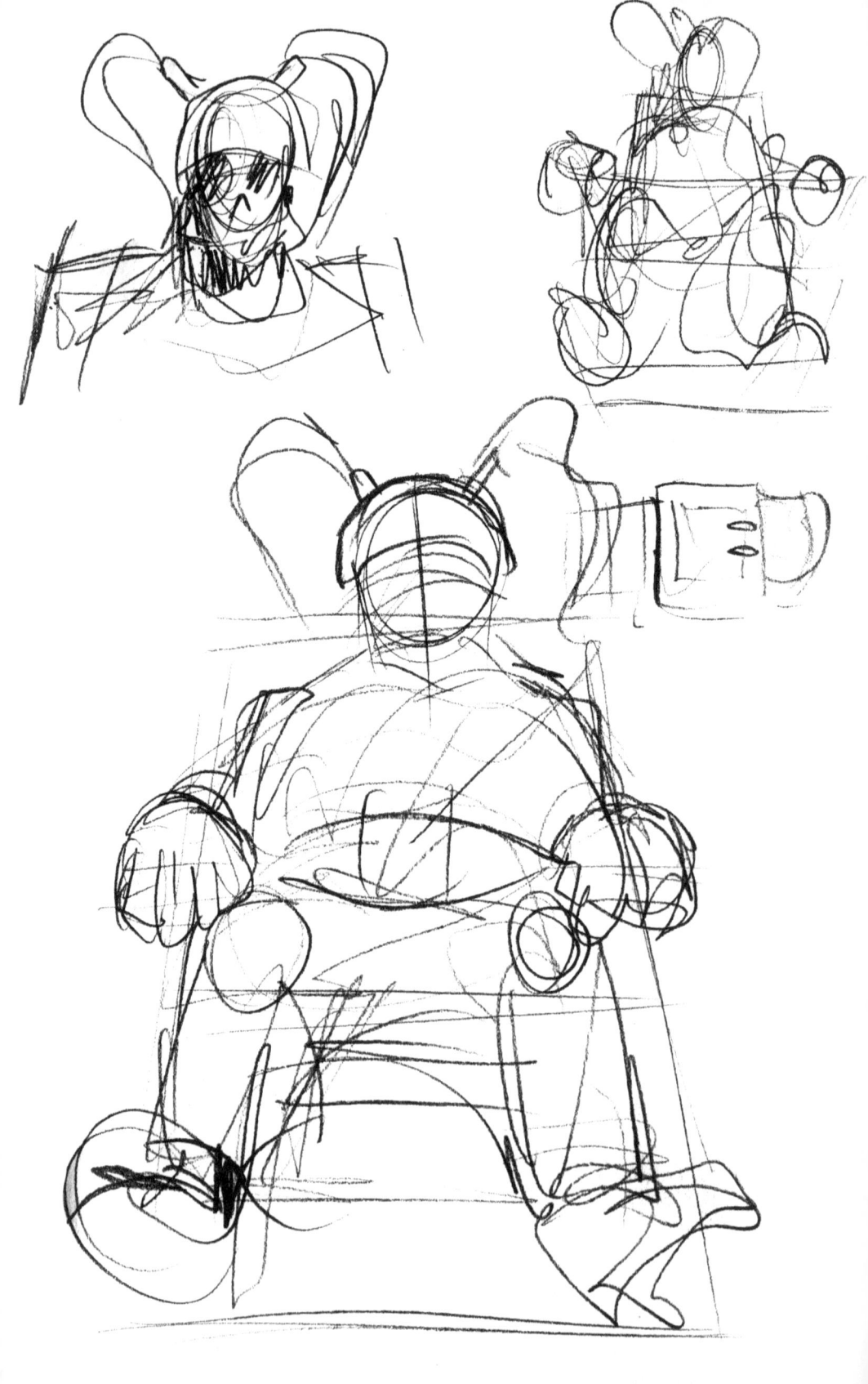

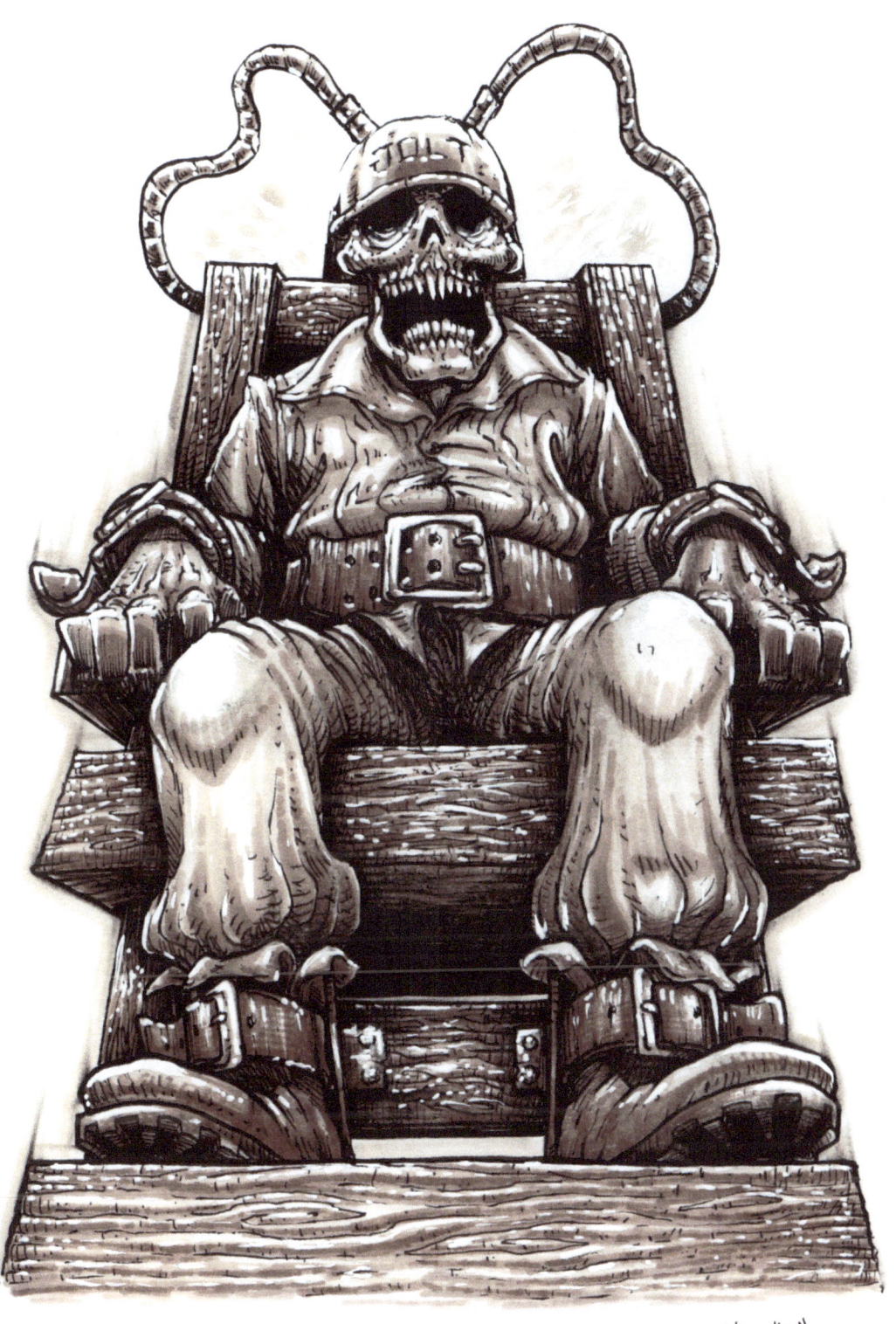

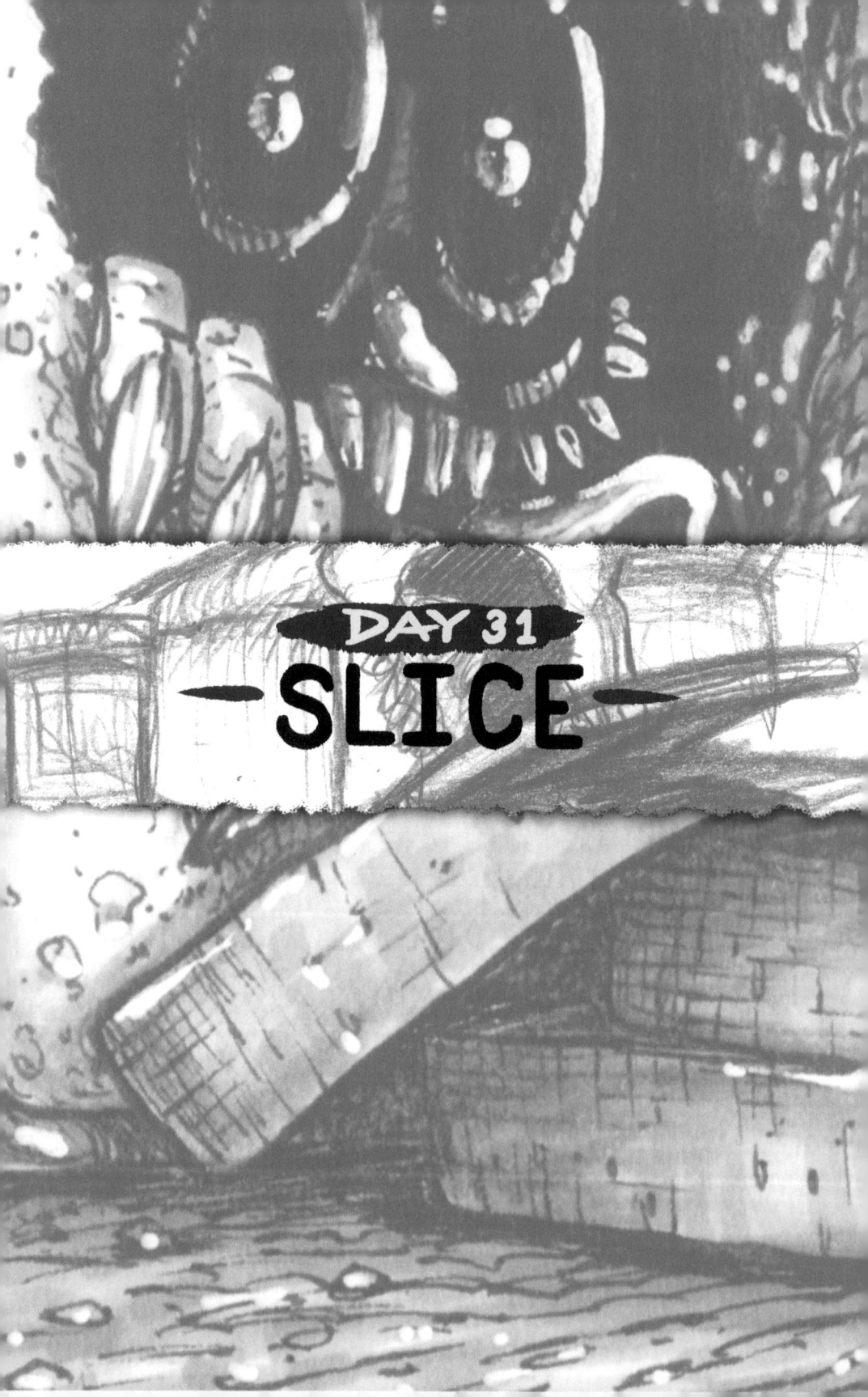

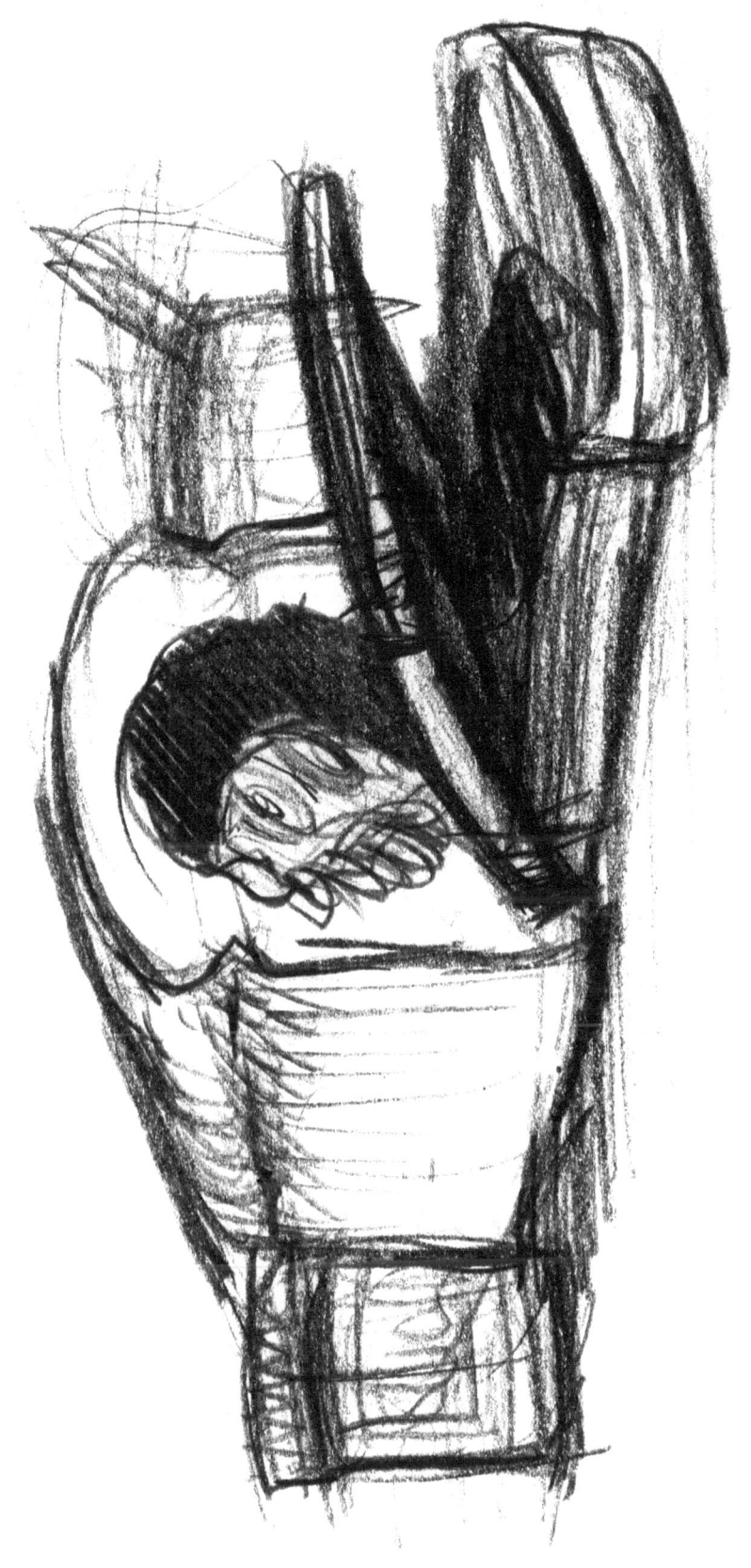

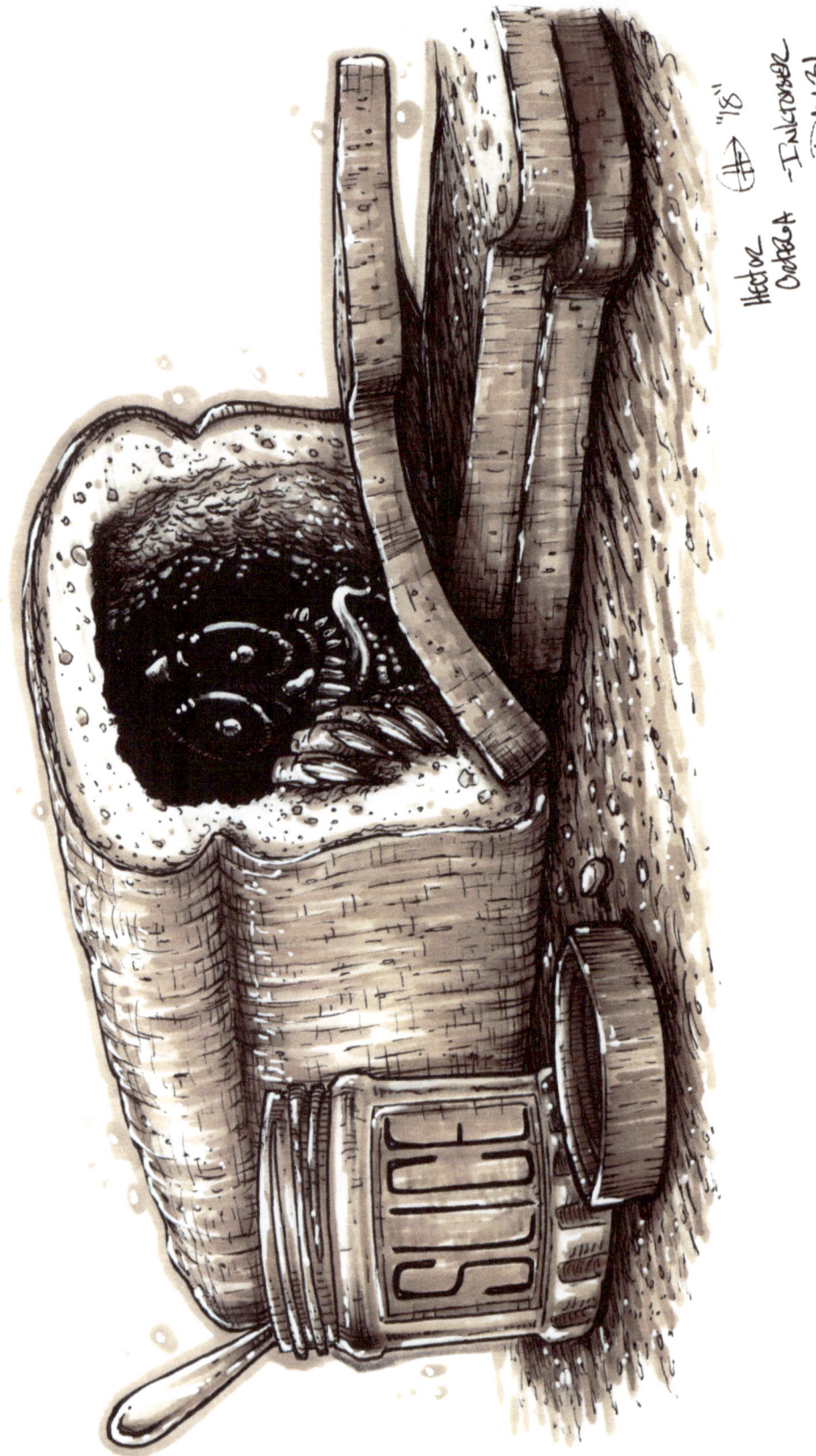

HIGH OFF MY OWN SUPPLIES
Art
of
HECTOR J. ORTEGA

ISBN: 978-0-692-13827-4

NOW AVAILABLE!

@hector2ortega
@artofhector2ortega
www.hector2ortega.com

www.ingramcontent.com/pod-product-compliance
Lightning Source LLC
Chambersburg PA
CBHW041059180526
45172CB00001B/29